Minifigure Customization
POPULATE YOUR WORLD!

W9-BYA-867

Table of Contents

Photo by Jared Burks.

Minifigure Customization: Populate Your World

Author: Jared Burks

Layout Artist: Joe Meno

Proofreader:

Contributing Photographers: Ace Kim, Andreas Holzer, Anthony Sava, Bluce Shu, Chase Lewis, Chris Campbell, Chris Deck, Don Reitz, Emily Brownlow, Ethan Hunt, Gaetano Dooms, Hazel-Tam, Isaac Yue, Jamie Spencer, Jason Burnett, John Arnst, Jordan Schwartz, Kevin Chu, Kris Buchan, Kyle Peterson, Larry Lars, Mark Parker, Matt Rhody, Matt Sailors, Moko, Nicholas Sims, Robert Hendrix, Robert Martin, Tim Fortney, Victor Sobolev, Michael "Xero_Fett" Marzilli, and Will Chapman.

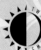 TwoMorrows Publishing
10407 Bedfordtown Drive
Raleigh, NC 27614
www.twomorrows.com • e-mail: twomorrow@aol.com
First Printing: May 2011 • Printed in Canada
ISBN-13: 978-1-60549-033-5

Trademarks and Copyrights:

Dedication

I would like to dedicate this book to my wife, who is my best friend. She has supported my insane exploration into this hobby and has endured many trips to the hardware, hobby, art, toy and assortment of other stores. Thank you Amber, for letting me spend too much time and money on creating toys.

I would also like to thank a few friends who have helped me and shared in the insanity: Chris, Mark, and Matt, many thanks.

I would like to thank all who contributed photos to the book. It would not be what it is without your excellent custom figures. Thank you.

Thanks to Joe Meno for his tireless efforts in assembling the book. Thanks Joe!

Finally, I would like to thank John Morrow for the opportunity to create this book. Thanks John.

Any student of history knows we build on the past, therefore a short review of the history of the minifigure will help improve your custom creations. Specifically, we can learn where LEGO has succeeded and failed so we don't repeat their mistakes and can recreate their successes in our designs.

The LEGO Company created the minifigure in 1974. This figure did not have functioning arms and legs, yet it changed the way we play with the bricks, allowing for role-playing. In a short 4-year period, by 1978, this figure was altered into the figure we know today. The first modern minifigure was a police officer. In total, 7 different figures were created for the themes of Town, Space, and Castle in 1978. These early figures as well as those created today are compliant with all LEGO system standards. Specifically, the minifigure body is three bricks high and the head is one brick high. The figure has the ability to hold LEGO bricks and it can be connected standing or sitting on top of other LEGO elements. It is this scale that will challenge your ability to create custom figures and parts for those figures.

Two months after the release of the initial 7 figures, the LEGO Group released the first female figure, a nurse. Back in those days, the torso designs were created with stickers and the figure's head sported the now classic smiley face. During this era, the goal was not to limit a child's imagination and play so the figures were supposed to have no gender, race, or role; these characteristics were to be defined by the child. The nurse sported a feminine hairstyle, so even from the beginning of minifigure creation LEGO has been conflicted in designing figures as the nurse went against their policy to not define the gender of a figure.

It didn't take the company long to develop the minifigure. In the late '80s with the release of the LEGO Pirates theme, minifigures needed to change their facial expressions from happy and neutral to happy or grumpy and good or evil. Figures also developed ocular issues requiring eye patches and required prosthetic hooks and wooden peg legs for lost hands and legs. These new figures helped drive sales of the Pirates theme to new heights hinting at the power of the tiny titan.

The minifigure had a big decade in the '90s as it was animated for the first time in "Panic on LEGO Island" and was incorporated in the first LEGO licensed product with Lucasfilm Ltd. to create the characters of the Star Wars galaxy. This resulted in many firsts for the figure; most importantly, this was the first time a figure took on a specific role as they represented the characters from the film. It also represented innovation of the figure itself as LEGO created the clamshell head to create Chewbacca and later used the same strategy for the Gamorrean Guard. In the late '90s LEGO had another first for the minifigure: the Native American Indian figures of the Western theme sported a nose. Also during the era the figure was spotted showing off its toes with the release of the Pharaoh Hotep in the Adventurers theme.

Some of the landmark LEGO minifigures that have been produced.

More of the landmark LEGO minifigures that have been produced.

In 2000, the LEGO Group created soccer player figures that stood on spring-loaded platforms, allowing them to become a functional element. From this step, the company launched basketball figures which placed springs directly in the legs of the figures. With the launch of the Basketball figure came the NBA figures which, for the first time, featured figures with more authentic skin colors. Also during this time the figure started taking on other ethnicities, which is evident in the Orient Expedition and Ninja themes. In 2004, all LEGO licensed products started featuring more natural skin tones as they represented real-world characters. This was started with the Lando figure in the Star Wars Cloud City set. This set was a bit confused for LEGO as Lando featured a more natural skin tone yet every other figure in the box was still yellow-skinned. With the release of more natural skin tones, this has freed the design palette to once again contain yellow. Designing anything that contained significant portions in yellow made the figure appear scantily clad or perhaps even nude. As a customizer, the decision will have to be made to use either yellow figures or the more accurate skintones.

Over the years, the LEGO Group has tried many different design options on the LEGO figure. The figure has been featured as knight, astronaut, policeman, racing driver, space warrior, Harry Potter, Santa Claus, Steven Spielberg, crane operator, football player, explorer, nurse, basketball player, Spider-Man, frogman, skier, fireman, skeleton, pirate, rollerskater, American Indian, queen, and the list continues to grow. The figure has had various ethnicities, expressions, noses, toes, flesh tones, etc. As many different designers created these figures, there has been a continuity issue with the minifigure. To address this, the LEGO Group has recently prepped a 300-page book on how to display and design the figure. This book was promoted in an internal memo that like (many internal LEGO documents) was leaked to the public on the internet. While we don't have access to this book, the memo gives away several "do's" and "don'ts" for minifigure design. Several of these new rules have been broken already by LEGO.

In the leaked article about the guide, the company states, "Since 1978 more than four billion minifigures have been manufactured with different types of clothing, equipment, and facial expressions. The minifigure lives on in many different versions – **but preferably not too different.**" It is this last statement that is concerning to the community of minifigure customization. By limiting the figure it limits our ability to "just imagine." This means we sometimes have to create from scratch to fill the void where LEGO leaves off. The leaked pages also reveal that a minifigure may not have a nose except in special circumstances and gives the example of the Clown recently released in the Collectible Minifigure Series 1. LEGO goes on to state that the figure was an accessory to the bricks, originally, but has become an icon today. Well, LEGO needs to realize the paradigm shift that in many cases the bricks are actually accessories to the figures. The article announcing the guide also notes that figures are not to have toes and that all designs will portray the figure as modest. As a creator, you will need to decide when to stand by the rules or examples that LEGO sets and when to break them.

After an examination of the minifigures supplied by the LEGO Group, it is important to figure out just what it means to customize the figure. Where does customization begin? Can you merely switch out the accessory, change the hair or hat, or alter the figure's leg color? This is a question that only the customizer can really decide. The way I define customization requires a vision, much like a sentence requires a complete thought. When you have a vision of a custom figure and proceed through a process of executing that vision to find or create the combination of parts needed to create that custom figure, you have customized and created something new. Merely switching parts around isn't really customizing.

Here are a few examples of some great custom figures:

A diverse assortment of custom-created minifigures, ranging from brickbuilt figures to modified figures. The figures are (from top, left to right) Gunner by Jordan Schwartz, Iron Man by Moko, Minifig Dissection by Kris Buchan, Boushh by Christopher Deck, the Watchmen by Jordan Schwartz, and Napoleon by Gaetano Dooms.

Kris Buchan's Darth Krayt.

Notice that several of the customs seen in these images use official parts (known as purist customization), decals, modified LEGO elements, commercially available third party parts, and new parts from scratch. Many consider purist customization as the most difficult; as this group of customizers commonly use parts in new and creative ways. The techniques used to create the custom figures seen in the montage in the previous page will be explained in the following chapters.

In the previous chapter, we have examined minifigures supplied by the LEGO group, which is important as it helps define a figure and where customizing starts. Now you need to determine what it means to you to customize a minifigure. Can you merely switch out the accessory, change the hair or hat, or alter the figure's leg color? Ask yourself: how much impact does it really make? Changing a leg color for example could be very impactful, if the right color was used, like flesh or yellow. Recall that customization requires a vision, much like a sentence requires a complete thought, therefore executing your vision of a figure results in a customized and newly created figure. Merely switching parts around isn't really customizing in my mind. As one last justification, when you sit to build something out of bricks, do you merely start randomly sticking bricks together or do you have an idea, no matter how vague, of what you want to build before you start trying to build it. A custom figure should be no different. You need to know what you are building before you attempt to build it.

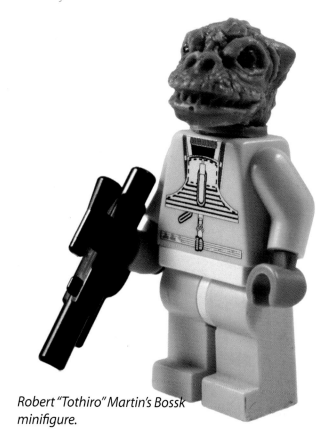

Robert "Tothiro" Martin's Bossk minifigure.

Moko's custom girl figure.

Purist customization can be simple and elegant, as well as complex and innovative. With the understanding of customizing gained in the previous chapter we can begin a discussion of purist customization. Purist customization is simply assembling figures using entirely LEGO-derived elements. Nothing is purchased from an aftermarket producer, scratch-built, sculpted, decaled, painted, or sanded; figures are entirely made from the palette of parts, designs, and elements that LEGO has produced and given us. Purist customizing sounds easy, and honestly it is where many customizers start, however it can be quite challenging and a great creative outlet. For this chapter I am going to break purist customization into three categories; traditional, non-traditional, and brick.

Traditional

Traditional customization is the most limited as it limits builders to using only minifigure parts. If it wasn't designed by the LEGO Group to use with a minifigure you can't use it. These parts are readily found in the Bricklink catalog categories with Minifig in the title (body part, body wear, head, head modified, headgear, headgear accessories, legs assembly, shield, torso, torso assembly, utensil, and weapon). This will limit what you can create; however there are thousands, if not millions, of different figures you can create using the palette that LEGO has supplied. Just remember you cannot alter any of the parts.

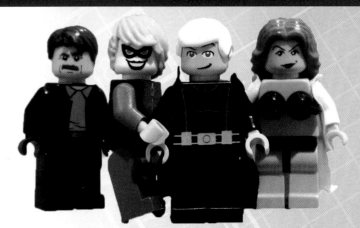

Blade Runner *figures, by Jordan Schwartz.*

A few more figures (right, far right, and below) by Jordan Schwartz.

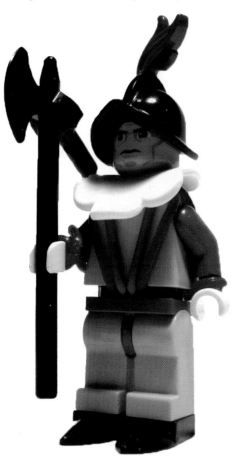

A figure by John Arnst of Norm Abram.

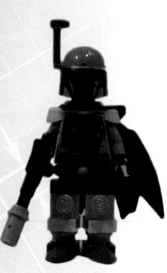

*Boba Fett built
by Gaetano Dooms.*

Historical Figure Contest

The best reference source for this technique is the Historical Minifigure Contest I hosted a few years ago (www. flickr. com/photos/kaminoan/sets/72157602244759515/). This contest produced brilliant figures by participants of all ages. This technique doesn't always require the creative stretch that some customizers use; simple and elegant approaches can create brilliant figures. If purist customization is for you the primary skill set is in-depth knowledge of the LEGO figure catalog. The best resource for this knowledge is the Bricklink catalog. There are thousands of minifigure parts, so finding out about all of them is difficult, however this variety allows for millions of combinations speaking to the volumes of figures you can create. The Bricklink catalog will also allow you to also see how LEGO originally used the elements.

Non-traditional

Non-traditional customization opens the door to any LEGO element; however the bulk of the figure is still created using minifigure elements. You will be completely surprised how people can incorporate and use LEGO elements in minifigure customization. Aliens, robots, and very odd minifigures are all possible when you mix bricks, especially when using bricks in conjunction with Star Wars robot and Exoforce themes' elements. All is possible with a bit of imagination and various bricks and other small parts. The figures can even look very stylish when some purists get a hold of the right LEGO elements. Non-traditional customization allows for some real ingenuity. Long before we had Ackbar some customizers figured out ways to create great likenesses of Ackbar using LEGO elements.

A couple of alien minifigures by Matt Sailors.

*Grenadiers
by Gaetano Dooms.*

A member of the Union Jack Black March built by Gaetano Dooms.

More aliens, this time by Jordan Schwartz.

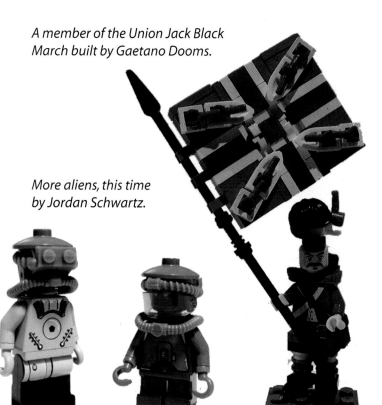

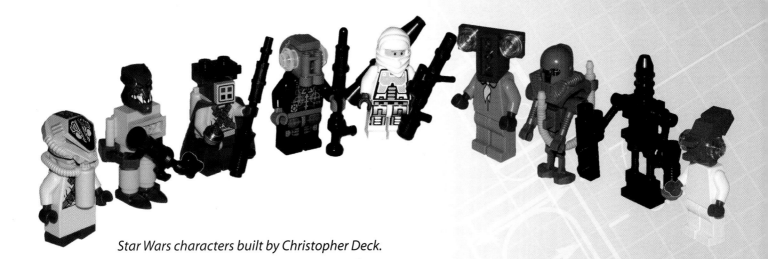

Star Wars characters built by Christopher Deck.

Brick

Brick-built minifigures are figures built in the minifigure scale entirely out of bricks, using non-traditional minifigure parts. Robots are typically easily built using this technique; however you will be amazed at what you can build. Here are a few examples that simply amaze me. This is a very powerful concept, and if you allow for the figure to grow slightly in scale, brilliantly articulated figures can be created that are no more than 1. 5 times the height of a minifigure. This really speaks to the creativity of many customizers.

This visitation to the world of purist customization has opened the doors to creative parts use. Using the bricks and the minifigure parts in new and creative ways will allow one to create almost any character. Purist customization takes a bit of imagination as you have to look beyond what LEGO has intended for the part and see how you can incorporate it into your creations. I would love to say that purist customization is the most economical form of the hobby, however with the growth of the hobby over the years many parts have gone up in price from a few cents to several dollars. Demand for parts has grown with the hobby's growth and in some cases it is now more economical to create your own part. With this information you must ask yourself, are you a purist or are you willing to paint, cut, glue, sculpt, and decal to create your new custom figure?

Napoleon on horseback, built by Gaetano Dooms.

Robby the robot, Santa's Ground Crew (with reindeer), and a brickbuilt toy soldier—all fan-built creations by Matt Sailors.

Cotton swabs and paintbrush, for decal work.

Before jumping off into any hobby, it is important to understand the tools needed to get real enjoyment from the hobby. In this chapter many of the tools will be outlined and if I can provide an economical source for them it will be noted. Please note sources referenced are in the US, where I am located.

The Customizing Toolbox represents the typical tools used for different customization techniques; these are by no means absolutes. When I started sculpting, I used paperclips, broken plastic forks —whatever I could find. This is merely a guide. Clearly the one group of parts you can't avoid is minifigure parts, which will not be covered here, so check Bricklink. This chapter will not cover the tool use, merely what is available, where to find them, and what skill set they apply to. The point of this chapter is to point you in the right direction early and hopefully save you a few dollars on the tools you do purchase.

Decaling

Software		
Draw Plus	www. freeserifsoftware. com/software/drawplus/	Free
Inkscape	www. inkscape. org	Free
Printer		
Printer	www. spoofee. com for deals	~$50
Decal Film		
Testors Custom Decal	www. testors. com/product/0/9198/_/Custom_Decal_System	~$10
Micro-Mark Decal Film	www. micromark. com/decalling. html	~$10
Total Cost		**~$60**

The foundation of minifigure customization lies in custom decals. Waterslide decal film is used to affix a new design to the minifigure parts. This part of the hobby requires a few items: vector art software, waterslide decal film, printers, decaling solutions, and application tools.

There are several vector art programs out there including CorelDRAW (my favorite), Adobe Illustrator, Draw Plus, and Inkscape. The last two are mentioned as they are free, which are great alternatives to the high-priced commercial options.

Waterslide decal film can be found almost everywhere these days (hobby and art shops) including Wal-mart. Typically decal film is about $1 per sheet. You can pick it up locally to avoid shipping fees. While these brands aren't the best, they are not bad to start with as they are generally a bit thicker and easy to apply. The most commonly found film is from Testors. If you can't locate this option, Micro-Mark offers an excellent film. Testors' film is strictly for inkjet printers, whereas laser and inkjet options are available from Micro-Mark. You must choose film that is designed to use with your printer (laser or inkjet). Please review the section on decal printing (page 20), especially if you choose an inkjet option as the decals MUST be sealed prior to dipping them in water.

The decal film type brings us to the next piece of equipment required: a printer. If you hunt around, you can find a real bargain on a printer — that is,

if you don't already have one. If you don't mind internet purchases check Spoofee. com or other bargain-finding sites for a few days and I am sure a deal will pop up.

Decal application tools are the next items required. Decal setting and softening solutions are critical to advanced application techniques and highly recommended. These solutions can be purchased at most hobby/model stores. The typical brands are Badger, Model Masters, and Microscale. Badger brands can be found at Micro-Mark. For others you will have to search online or locally (Model Masters is fairly common and can likely be found locally). The free option is diluted white vinegar (2 drops of water to 1 drop of vinegar). To apply these items you will need some small brushes. I recommend inexpensive nylon brushes, which can commonly be found at dollar stores. I prefer nylon because they seem to last a bit longer. Wood stick cotton swabs and tweezers are also very helpful and can be purchased economically at a pharmacy. Decal sealants are also needed and are merely clear paint; spray cans offer the easiest application. You don't need an airbrush, merely buy spray paint. Model Masters has a great clear lacquer option; however the $3-5 clear Krylon at Wal-mart works well. Before spraying, ALWAYS make sure the nozzle is clean so it won't splatter when you spray your decals or figures. Also make sure the decals are completely dry first.

Parts Modification/Creation & Color Alteration

General		
Hobby Knives	www. harborfreight. com/cpi/ctaf/displayitem. taf?Itemnumber=96551	$13
Hobby Knives	www. harborfreight. com/cpi/ctaf/displayitem. taf?Itemnumber=32099	$6
Rotary Tool	www. harborfreight. com/cpi/ctaf/displayitem. taf?Itemnumber=92880	$30
Rotary Tool	www. harborfreight. com/80-piece-rotary-tool-kit-97626. html	$10
Kevlar Glove	www. harborfreight. com/cpi/ctaf/displayitem. taf?Itemnumber=66062	$4
Micro-mesh	micro-surface. com/index. php?main_page=product_info&cPath=273_188_189&products_id=53	$47
Paint		
Testors Paints	www. testors. com	$10
Dyes	Vinyl or Fabric - Auto part store or Wal-Mart	~$5
Preval Sprayer	www. prevalspraygun. com	~$8
Sculpting		
Sculpey III	www. sculpey. com	~$2
Dental Tools	www. harborfreight. com/cpi/ctaf/displayitem. taf?Itemnumber=1816	$3
Carving Tools	www. harborfreight. com/cpi/ctaf/displayitem. taf?Itemnumber=34152	$5
Clay Shapers	www. texasart. com/g11/Colour-Shaper-Modeling-Tools. htm	$6
Molding and Casting		
Smooth-On Kit	www. smooth-on. com/Getting-Started-Po/c4_1217/index. html	$50
Micro-Mark Kit	www. micromark. com/COMPLETE-RESIN-CASTING-STARTER-SET,8174. html	$90
Total Cost		**$120**

Modification tools can vary widely from one project to another, but the basics are hobby knives (X-acto®) and rotary (Dremel®) tools. If you buy name-brand versions of these tools, prepare to spend quite a bit of money, however. Very nice alternatives can be found at Harbor Freight for very little money. Harbor Freight is a US brick and mortar store with an online shop, so if one isn't near, you can buy online.

If you choose to go into the store, make sure to print the item details from the online store. The brick and mortar prices are slightly higher and they will price match their webstore. Remember that knives are sharp and can cut you as easily as your project, therefore I recommend a Kevlar glove, which can be found online at woodcarving stores or Harbor Freight.

Please know that many alterations can be achieved with sandpaper, which is safer for your fingers than a knife. A local home improvement store will have sandpaper, but I doubt you will find any paper of grit 800 or higher. To polish plastic back to a high shine you really need a very high grit paper (~12,000). Micro-mesh makes professional grade cloth-backed sandpaper that will last for quite some time. They are expensive compared to the home improvement store option, but in this case I completely believe it is worth the investment. Micro-mesh makes a kit for wood turners to make writing pens, and there are resellers on eBay that have these cheaper than anywhere else I have found. The turners' kit contains 9 sheets of 3 x 6 inch sandpaper with gradually increasing grit increments from 1500 – 12,000. Using these in series will leave sub-micron (VERY TINY) scratches that are only visible to a microscope, thus leaving your project with a high shine. These papers can also be used in sculpting.

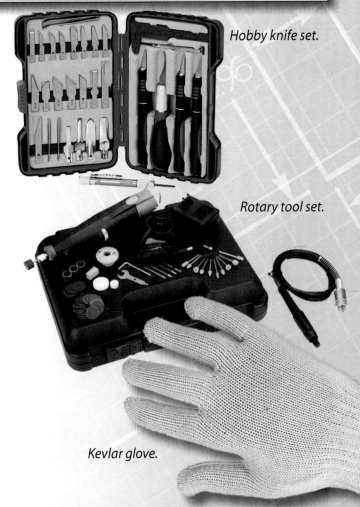

Hobby knife set.

Rotary tool set.

Kevlar glove.

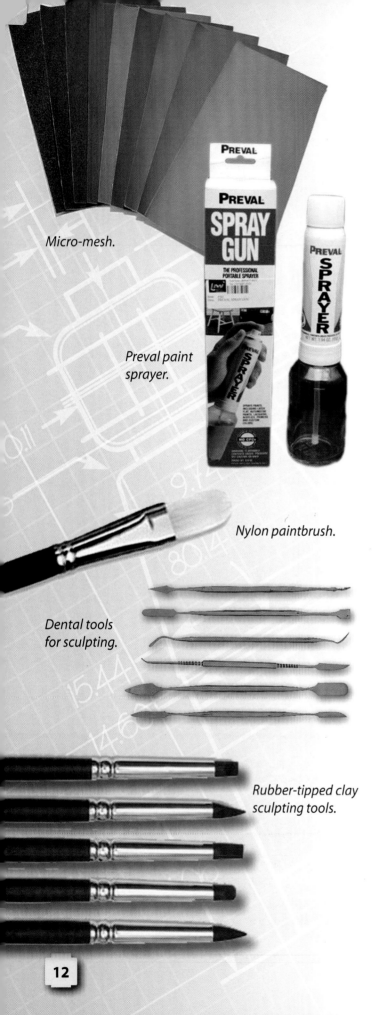

Micro-mesh.

Preval paint sprayer.

Nylon paintbrush.

Dental tools for sculpting.

Rubber-tipped clay sculpting tools.

Paints and Dyes

Of all the tools needed, paints are the easiest to find. You can pick up Testors hobby paints cheaply at most stores. Look for the primary color bulk paint packs, these typically run $5-10 and have 8-15 paints of various color in them. These paint packs are a very good value for your money. With a primary color pack you can mix and make most any color. The hobby uses small items that don't require much paint, so mixing your own paint with a few drops from a bottle works great. Sometimes these packages come with brushes, sometimes they don't. Recall from the previous section that dollar stores commonly offer assorted brush packages, so one purchase can have two functions (painting and decaling). Even if most brushes in the package are not useable the few that are will be worth the price, so check an art store's pricing for one or two brushes. Personally, I like nylon brushes as they last quite a while. Typically nylon brushes have white or brightly colored bristles of uniform color.

There are alternatives to painting such as vinyl or fabric dyes. These are much more permanent alterations to the parts and typically cannot be removed by scratching the part as they absorb into the plastic. Vinyl dyes can be found at automotive stores, the drawback is it is typically only available in limited colors. Just be sure you are purchasing a vinyl dye and not a vinyl colorant. Refer to the color alteration section for the difference (page 28). Fabric dyes are available most anywhere including Wal-mart. The liquid versions seem to work better, so search these out instead of the powders.

An airbrush is a nice tool to have, but not always cheap. The low-cost option is about $30, but these are really only good for broad coverage and don't always meet every need. Investigate this tool heavily and only purchase when you are sure you have a need. A much cheaper alternative to an air brush is a Preval paint-sprayer. This system has a container you can add any paint to and turn it into a spray paint.

Sculpting (Clays and Tools)

Packages of sculpting clay are very economical and can be found most anywhere. You can work with the clay with homemade tools: paperclips, tongue depressors or popsicle sticks, and anything else small. However, some economical tools are available from Harbor Freight. There are more expensive options at art stores that have rubber tips or made from surgical stainless steel that are quite nice, so ask yourself how much sculpting you are going to do. Most often the lower priced tools are more than enough.

While the rubber-tipped modeling tools mentioned above are not absolutely necessary one or two can be helpful. These typically cost about $6 per tool. Luckily I find them locally, but depending on where you are you might have to look online. These tools are really quite nice and work great as they allow for very subtle detail work.

Baking sculpting clay uses your home oven (no expense) or you can cure it in near boiling water. Practice clay sculpting BEFORE getting into molding and casting as they can get quite expensive. Not every piece needs to be molded.

Molding and Casting Kits

Molding and casting can get expensive quickly and are more technically demanding than any other part of the hobby. If you choose to go this route, check what is available locally. I recommend starting with a kit that contains both rubber and resin; both Smooth-On and Micro-Mark offer these types of kits. I don't recommend Alumilite as you get half the volume of rubber when compared to other options for the same price. As this is the most expensive and complex off-shoot of the hobby, just as with the airbrush, weigh your needs before purchasing.

Cloth Accessories		
General		
Leather Punch	www. harborfreight. com/leather-punch-tool-97715. html	$7
Scissors		~$5
Total Cost		**~$12**

For cloth, outside of the material and a pair of scissors, there is really only one tool, a multi-punch leather tool. A leather multi-punch works well, but is not as nice as what Mark "MMCB" Parker uses. Mark drives the innovation of this portion of the hobby and he prefers a set of metric wad punches. However, the leather multi-punch will give good results and is significantly cheaper. Harbor Freight also carries this item as well. Finding a metric set of punches is quite difficult, an English version can be used, however it doesn't create holes to the exact dimensions of the LEGO figure's neck and arms. You will also need a nice pair of fabric scissors to cut the fabric to shape.

Leather punch.

Cloth is cheap and can be found at any fabric store. Remember you don't need much for minifigures; so check the scrap and discount areas. Another alternative are pre-cut quilting squares available at many stores. Just make sure you are buying broad cloth, if you want to stay with a similar fabric to what LEGO uses. You will also need an anti-fraying solution, which is also available at the cloth store.

Photography/Digital Effects		
General		
Ifranview	www. ifranview. com	Free
Light Tent	Photography section for DIY	
Total Cost		**Free**

Digital Editing

Please visit the Digital Photography section (page 68) to find out how to make your own economical light tent. If building one isn't your cup of tea, there are many versions available online for a wide range of prices. Many include lights and backgrounds, so make sure to look for a deal. As for digital editing, Adobe Photoshop is the standard. However, it is hard to beat the free Irfanview program if you are on a tight budget as it can be used to do many editing functions.

So if you want to dive completely into the hobby with the best options as I see them you will have about $220 worth of items

to purchase, including a printer. I don't recommend starting the hobby by purchasing every item; figure out what you really want to try first. Work on the skill set required for that area of the hobby and once you have perfected it, then move on to another area. I would buy the least expensive items first and then move on to more expensive options as you improve your skills. You don't need expensive equipment to get great results, mainly just time and practice.

- Printed Ink
- Clear Transfer Matrix
- Adhesive layer
- Dextrose Adhesive and Release Layer
- Blue Paper Backing

Waterslide Decal Film

Waterslide decal film is just as it sounds: a thin film used to transfer a design to a surface using water as a releasing agent. Specifically, ink is printed face-up on the waterslide film, which relies on a dextrose corn sugar residue to release the film from the decal paper and to assist in the bonding of the film to a new surface. Better quality decal film also has a water-based adhesive layer added to improve the bonding of the film to the surface. The film itself is typically made of lacquer.

Waterslide film is much thinner and capable of taking on complex curves, something that many other decorative techniques (such as vinyl stickers) are not. Also as waterslide film is printed, it can be produced with very high levels of detail. Until recently, waterslide film was only available through professional printings; however with the advent of printable film for inkjets and laser printers, as well as color copiers, custom decal creation at home using waterslide film has become accessible. Because of these characteristics, waterslide film is the method of choice when it comes to customizing figures.

Designing Decals

Designing decals sounds easy: draw a picture of what you want your custom figure to look like using a computer. While this sounds easy, there are many aspects that are critical to achieving good results. The aim of this chapter is to get you to think about the end result while creating the decal. To begin this topic we need to understand how different art programs create graphics, specifically raster and vector formats.

The Foundation: Raster vs. Vector

Raster image formats are made of tiny squares of color called pixels; these are primarily used in digital photography. The main graphic formats of the web, GIF (Graphics Interchange Format) and JPG (Joint Photographic Experts Group), are raster formats. When you zoom in, these images become blocky (or pixilated). Think of a LEGO mosaic when you can see a raster picture, stand far away you see a picture, stand close you see squares. This image format will always have the limitation of the pixel size.

Raster Image: All digital photographs are raster-based images, if you zoom enough or the dpi is low enough the pixilation will be visible.

Vector formats are not based on a square pixel but mathematics, as such, images will never appear pixilated. EPS (Encapsulated PostScript), to some extent PNG (Portable Network Graphics) and native formats like AI (Adobe Illustrator) and CDR (CorelDRAW) are vector formats. When you magnify vector art, it stays sharp and clean because the same math applies at whatever the magnification. Think of looking down railroad tracks, they never meet and will never meet, even using binoculars, you maintain resolution despite the magnification. In a raster format because of the pixel size limit the tracks will

meet when magnified. Vector graphics are used in illustration and design (commercial artwork). Most home users, doing simple web graphics, drawing pictures, or photo editing don't have a need for these formats. However, for the best results it is important that you create your designs in a vector art program. If you don't have a vector program, consider using trial versions of the aforementioned programs or for free programs check out DrawPlus 4 or Inkscape (check the Toolbox chapter for links, page 10). If you don't want to use a vector art program, raster programs like Adobe Photoshop can be used, just remember to set your dpi (dots per inch) as high as possible. This value is the resolution of your image, thus the size of your pixel, which is tied to its print quality.

Color

Color is a complex topic. Let's consider the two formats used to create and display color, RGB and CMYK. These two formats result from the difference in the behavior of light mixtures (additive color) and pigment mixtures (subtractive color). What this means is that color is created by two very different phenomena. When light is perceived by the eye we are examining the wavelength of the light in the visible spectrum. When this light is separated by a prism you can see all the colors that add (additive color) together to make white light. As you move up the wavelength you proceed through the colors (Violet, Indigo, Blue, Green Yellow, Orange, and Red). When you see color from an object, it is the result of the reflection of light off that object. Specifically, all colors except the reflected color are absorbed by the object, thus this is subtractive color (all colors are subtracted from the resulting color as they are absorbed by the object). Therefore we have two formats to use create color, RGB and CMYK. To understand why this is important consider how each are used.

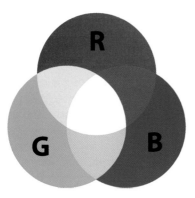

RGB (Red, Green, and Blue) values are mixed by addition to create all other colors. These are primarily used in TVs and other display devices where they represent small color elements that when mixed make every other color. White is achieved by mixing red, green, and blue in equal value. RGB color format is most commonly used in raster imaging and will look best when presented on a display device like a monitor, projector, or television.

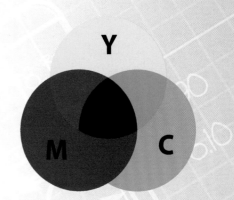

CMYK (Cyan, Magenta, Yellow, and Black) values are mixed by subtraction to create all other colors. These are used in printing devices and benefit from having a true black color. CMYK color format is most commonly used in vector imaging and will look best when printed. Printers predominately use the CMYK format, thus if you create your graphics in a CMYK format the colors don't have to be converted from one format to the other before printing. This format doesn't always look the best on the screen as the colors are converted before displaying in RGB, but the goal is the final printed version, not the intermediate.

Thus, when choosing a color format weigh the objective: in this case it is printing your decal designs. Check your printer, as most use CMYK. If this is the case, design in this format. Luckily, the CMYK and RGB color values are published on Peeron for the LEGO color palette (www. peeron. com/cgi-bin/invcgis/colorguide. cgi and www. peeron. com/inv/colors). If you utilize colors from the LEGO color palette any design you create will appear at home in your LEGO structures and vignettes. Remember that every printer is slightly different and any color value used from the published palette might not be exact, but it will be very close. As such, small test printings to perfect the color match can be performed. Remember to check the color against applied decal designs, not merely printed designs as the final application could alter the color slightly.

Templates

Once you have selected an art program and become familiar with it, the fun can really start. The first thing you will need is a template of the LEGO minifigure. With a template you will know the exact size to design any decal. To create a template, grab a metric ruler and a pen and paper. Merely take the part you are designing for and accurately measure the outside edges. Then redraw this structure in your art program to the exact dimensions. While this sounds easy it can be challenging due to the curvature of certain body parts. These surfaces can be measured using fabric tapes. Another trick is to place the body part on a piece of paper and trace the part; measure the resulting tracing.

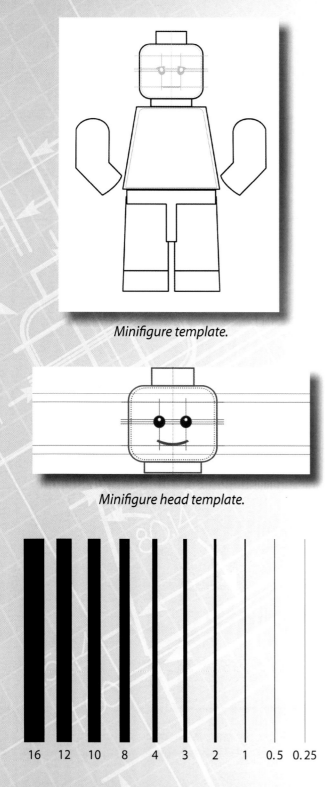

Minifigure template.

Minifigure head template.

| 16 | 12 | 10 | 8 | 4 | 3 | 2 | 1 | 0.5 | 0.25 |

Line Weights: The following is a simple representation of line weights, thinner lines are used for fine details, thicker lines for bold details.

By creating everything to scale it avoids conversion errors when it is time to print. The basic template is on the left, please note that the decal area of the torso is ~1.42 cm x 1.2 cm, the hips are 1.4 cm x 1.1 cm, and the legs are 1.42 cm x 1.2 cm). Many other templates can be downloaded at a site I helped found, Minifigure Customization Network or MCN (www. MinifigCustoms.com).

The minifigure head is a unique body part that is out of scale to the rest of the figure. As such, designing appropriately for the head is quite difficult in relation to the rest of the figure. To begin, let's think about the scale of the minifigure face. Let's review what the LEGO Company has done to better understand the dimensions of the minifigure face. The rule of thirds, a concept taught when sketching the human face still applies; basically divide the face into 3 equal portions vertically. This allows for the scale and placement of the facial features in scale to the head (Top of brows, Center of eyes, and Bottom of mouth). Decal designs featuring hair require the decal to flow onto the curve of the minifigure head to allow the decal to be properly placed in relation to minifigure head accessories, which would occupy the space above the brow line. Please see my template to the left. This template helps me keep the face in proportion to the LEGO head. I have placed several reference lines on the template; from top to bottom, Center of rounding-top, Top of brow, Eye Twinkle, Center of Eye, Twinkle Low, Bottom of Mouth, and Center of rounding-bottom. This template also includes the complete wrapping area in case the design needs to completely encompass the minifigure head, which is why the lines extend beyond the face. A complete wrap is 32 mm long by 8.4 mm high.

For an extensive study of the LEGO Minifigure face please check out the work done by Kurt "Capt. 5p8c3" Meysmans' in his Flickr guide for the minifigure head. He demonstrates how several official faces fit a similar guide (www.flickr.com/photos/26161965@N06/3507059999/). He also supplies great examples of beards and mustaches and the aforementioned inclusion of hair in the face design.

Remember Your Printer

When creating art for minifig decals, it is important to remember the limitation of your printer. Most printers have difficulty in printing a line with a weight less than 0.2 pts (Line weight refers to line thickness, think of a line drawn by a #2 pencil compared to a mechanical pencil). Just because you can see the difference in your vector program doesn't mean you can print it, test printing is important. Vector programs can create art beyond the abilities of home (non-commercial) printers due to the nature of vector art. A good point size range for details is 0.3-1.0 pts.

If a highlight or fine detail is required the smallest line weight I will use is 0.2 pts. I do this for several reasons: 1, I draw designs for many people and want them to have good results when printing (Various printers/color copier types); 2, I convert to jpg format (a lower resolution format for compression into a smaller file size for easy up and download from the web), this means I lose some detail, and thus my details need to be bigger; and 3, I try to stay in a similar design scheme as LEGO.

With the basics out of the way let's discuss decal design style. I am sure at one point in your life you have seen a cartoon. Cartoon styles run the gambit from Mickey Mouse to very risqué scantily clad superheroes. In order to draw a design you need to decide or discover your design style; actually you don't even have to limit yourself to a single style. For example, the LEGO Company is confused about its design style; examine the older versus newer figures or for that matter across LEGO themes. Most recently, some internal memos have leaked from LEGO that reveal the fact that the company is trying to address this very issue with the release of an internal 300-page book that defines how minifigures are to be represented and created. In order to help you define your style let's examine others work. This way, we can better understand what we like and dislike. Therefore you can better translate your favorite character into LEGO form. Let's visit variations in the official LEGO design style; I bet you may never have noticed many of the options LEGO has included in their design palette. Bricklink is a wonderful reference for information on various official LEGO minifigure designs produced over the years.

2D versus 3D

Our favorite minifigure started out ages ago with simple 2-dimensional designs that adorned its chest and head. These designs are simple and quite easy to create and can still be used to capture most custom figure's needs. Please consider 2D designs when creating a new custom figure decal. With time and the modernization of the minifigure design, the styles used have become more complex including drop shadows on ties, belts that flop off the figure, curvy pockets and necklines, and cloth wrinkles. These all attempt to add depth or a third dimension to a design. They make the flat surface look more than it is and give the illusion that the figure surface is textured. The female hip area on the Slave Leia Minifigure is a classic example of this illusion. These features can add a great flair to a design and give the figure more shape.

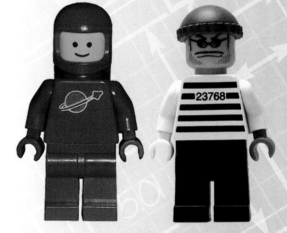

Classic 2D decal style.

Expressive Faces

The simple smiley face has come a long way, however it is still at home in the LEGO-verse. Today's smiley features pupil reflections. However, once LEGO crossed into the world of Japanimation with Exo-Force and Avatar themes, expressions took on a whole new meaning, giving the characters more complex emotions. This is not to say that LEGO didn't have the occasional scared or grimacing face, but these themes seemed to free LEGO to dive into a whole new series including the Christmas carol singer with rosy cheeks and a tongue. While the customizing community has been adding more expressions for some time, especially the stop-motion animation film makers, LEGO just now seems to be catching up.

As a customizer we can do better to capture those grimaces, snarls, frowns, and overjoyed expressions. This

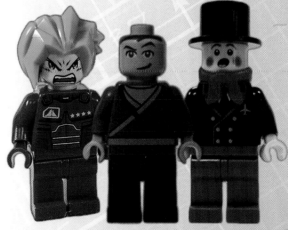

Newer expressive faces.

Expressions, photo by Jordan "SirNadroj" Schwartz. Notice the humor he employs by using the "O" expression to show the figures surprise.

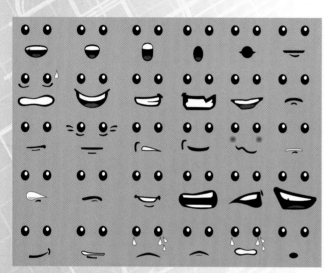

Basic expressions: Row one includes the basic vowel sounds (A, E, I, O, and U). The faces continue through the basic emotions. Notice that in some cases the mouth needs to be oversize to complete the expression.

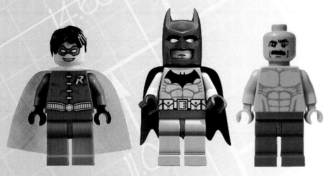

Some examples of LEGO minifigure musculature.

is especially true with today's generation who has grown up with instant messaging and texting services with the plethora of emoticons (These same emoticons can serve as inspiration or foundations for your expression creations). Why can you express emotion in a text message and not in a custom figure? Make sure you make your figures as expressive as they can be.

Knowing the scale of the face (pg 16) we can start to imagine the different expressions we can create. It is important to match the minifigure expression to the figure and to the surrounding. By making the expression fit the surrounding, you will find that this small area of the figure's face can add humor or interest to your figures and MOCs. Just some of the expressions for the standard figure I have created are presented to the left. In this photo by Jordan "SirNadroj" Schwartz, he has added humor in displaying the minifigure expression by using the construction worker with the shocked expression.

The expressions presented in the photo are presented in flat form to the left. Most of these were inspired by cartoonists facial expressions and the basic vowel sounds (A, E, I, O, and U) to allow the figures to have almost life like speaking mouth movements. If you look into the basic cartoon shapes of the human face many expressions can be extrapolated into LEGO form. Remember that facial expressions don't stop with two eyes, two brows, and lips. I have added tattoos, scars, ears, noses, ear rings, nose rings, and much, much more. If you see it in your inspiration add it to the design.

The next time you sit down to create that favorite figure, ask yourself what expression he or she would commonly wear. Once you have established what the common expression is, think about how you could take your figure to the next level by adding something a little different. Give your figure a bit more character by expanding his or her facial expression.

Musculature

Musculature is also something that is still relatively new to LEGO designs and seems to still be evolving in LEGO designs. When LEGO tackled the Spider-Man theme it introduced muscle designs as a base to the outfits Spider-Man wore. These evolved in the Batman series seen in the image below. Notice that Robin's muscles are shaded, where as Batman's are very rigid. I assume that this is meant to show Batman's armor is thicker or his muscles are larger. The musculature changed with the introduction of the Bane character. Bane is a heavily muscular villain and LEGO needed to show that he was bigger than the Bat. This design was recycled in the German Mechanic from the Indiana Jones theme, Dastan from Prince of Persia theme, and the Surfer from the Collectible Minifigure Series. So now a normal mechanic is bigger than Batman. This is an inconsistency that needs to be avoided if you are creating a series of figures. Make sure you are staying consistent with your designs. Also, like LEGO, it is best to reuse design elements like the musculature as this makes the figure designs appear to be more cohesive.

Oddest Features

I bet many would make the statement that the LEGO Group has never included toes or a nose in a minifigure design. Well, you would be wrong, the company has done both. I have a good friend that swears by the inclusion of a nose in a face design. I, myself, have included them in a design or two as I just couldn't get the feel of the character without one. Feel free to be open to new styles, if you lock yourself into what LEGO has done, or commonly done, you won't grow in your design skills. Over the years I have been designing minifigures my style has dramatically changed and I have different styles for specific themes.

Old versus New

Everyone's style will change with time. The more you design the more other's work will influence your work. This is because you better define your style. Look at the new Pirate's theme versus the classic. The soldiers and captains have changed dramatically. The older designs were more flat 2D designs, where as the new designs encompass more of the 3D effects and utilize more color. Be sure to keep this in mind when designing. Watch for the growth in your design style, typically these come as you better learn the program you are using to create them.

Perspectives

Now that we have closely examined LEGO's design palette for the figure, what did you like and dislike? How would you tackle an iconic figure like Superman? Obviously he needs a red cape, but what about the torso design, specifically the S icon and the musculature? People see this differently; just look at the comics, films, and TV shows. There is always variation to his design. Here are a few-fan created versions, just to demonstrate this practice.

So now that you have seen some variations on the theme of design, how would you create Superman, or for that matter your favorite minifigure?

A minifigure with a nose? A minifigure with toes?

The new minifigures step forward from their older designs.

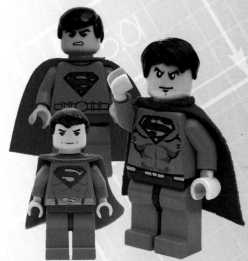

Superman, Bottom left created by Bluce "Arealight" Shu, top left created by Isaac "RedBean" Yue, and right created by Chase "Vid" Lewis. Please note that these are fan-created versions of the DC comic book character Superman. DC retains all rights to the character.

This chapter will begin with the best advice I can offer: before printing on any expensive media always print a test page. Print your designs on a piece of scrap material or paper. Confirm your color choices, as colors on your screen will not exactly match printed colors (RGB vs CMYK typically, see color section page 15). Also confirm your details: you may have been working on a magnified design in a vector art program that is actually quite small when printed; are your details too fine to print?

At the beginning of the decal section, I explained the nature of waterslide decal film. It is very thin and clear, and when applied correctly, the design will appear as if it was printed directly on the figure. The result should resemble the appearance of a LEGO printed element. Waterslide film is available from hobby stores or online. I recommend the film sold by Micromark (www. micromark. com); they have a sample pack of clear and white film. Clear film will work well on any of the lighter colored LEGO elements; however dark elements create a problem which requires you to use a special printer or use white decal film. This is because the darker LEGO element will show through the printed regions darkening them and in many cases will completely conceal your design. This is due to the fact that the inks don't have the opacity to stand out on the dark elements, because they were designed to print on white paper. If you use white film, this gives your design the ability to keep the vivid colors on dark elements, however, you will now have to print the torso color or closely trim your decal. Printing the torso color will require a close color match to the torso (or the decaled element), so be sure use to use the references listed on Peeron and Bricklink mentioned in the color section (page 15).

As most people have access to inkjet and laser printers or color copies (Kinko's, etc.), the instructions to follow will outline how to create decals using these types of devices. Make sure you select the waterslide film that is appropriate for your printer or copier. Print your designs using the highest resolution possible for your printer (just like you did when performing your test print). Once printed, be very careful not to handle the sheet of decals until the ink dries. This may take some time, especially if using an inkjet. The decal film isn't absorbent; the ink sits on the surface. This means smudging is very possible, so be patient. Overnight drying is best. After you have printed using an inkjet or color copier, you must add a clear overcoat to the decal film, specifically a clear spray paint available at any home improvement store. I recommend a Krylon UV-resistant clear spray paint. This is required because the ink is NOT waterproof on decal film regardless of what the printer's manufacturer states about their inks. Apply several thin coats of clear sealant and allow it to dry between applications (2-3 applications normally does the trick). This will protect the ink from the water used in the application of the decal, **use of a sealant is critical**! Once printed and sealed the decals can be cut from the page for application.

Spray sealant, available at home improvement stores.

With the knowledge of how to create waterslide decals, one needs to conquer the next needed skill, application. Waterslide decal application is quite easy and can be done by most anyone. There are basic application instructions, which work well for flat surfaces and advanced instructions, which are needed for complex curves (helmets, arms, and odd parts). Before you apply a decal to any LEGO element, you need to start with a clean slate or brick in this case. This means you need an unprinted part/torso. Don't have a torso without any printing? No problem. A quick trip to the grocery store, Wal-mart, or most any hardware store will get you what you need to solve that problem: A $3 bottle of Brasso® micro-abrasive metal polish. Brasso, or any micro-abrasive polish, can be used to polish or sand the printing off any LEGO element. Micro-abrasive polishes include toothpaste, metal polish, and some other cleaning agents. Brasso is the easiest to find and the one that works the fastest. It is also great for removing scratches on older bricks or improving the transparency of older cloudy transparent bricks. It is a great product for any builder to have and one bottle will practically last forever.

Brasso Instructions:

1. Pour a small amount of Brasso (about the size of a quarter) on a paper towel or cloth.

2. Place the cloth containing the Brasso on a flat surface with the Brasso side up (Please note DO not place the cloth on a surface it could damage).

3. Rub LEGO element or minifig part vigorously against cloth containing the Brasso. Apply more Brasso if necessary. Removing the printing from a torso should take 15 seconds to 1 minute depending on how much elbow grease one uses.

4. Once the original print has been removed, wash the LEGO element with soap and water, making sure to remove any residual Brasso. Rub the element dry with a clean paper towel and verify all Brasso residues were removed. Stubborn Brasso can be cleaned up with a cotton swab.

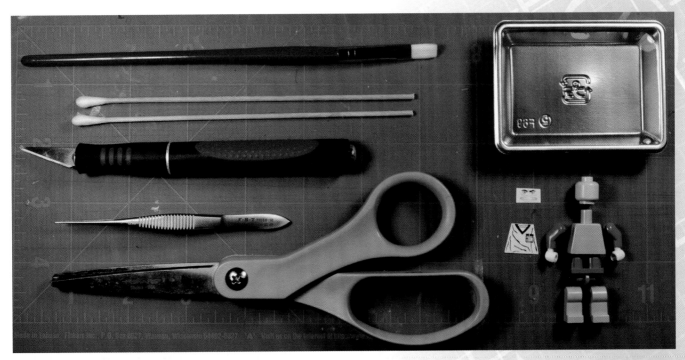

Now you have an unprinted LEGO element ready for application of your newly designed decal. This can be done by either the basic or advanced methods. The difference is the advanced method helps the decal to conform and adhere to the surface a bit better than the basic method, but it requires a few more reagents. The basic method will be covered in the next pages and the advanced in the following section. Before you begin, gather the few items together that you will need for application, these include:

1. Small paintbrush
2. Q-tip® or cotton swabs
3. X-acto® Knife
4. Tweezers or forceps
5. Pair of scissors
6. Tray of distilled water

Basic Waterslide Decal Application Instructions:

1. Disassemble the minifig completely. If the minifig has printing that needs to be removed use Brasso to remove the printing (see previous page for instructions). Wash and dry the minifig after using the Brasso to removing any residual abrasive residue.

2. Trim the decal with scissors or an X-Acto Knife preparing it for the distilled water.

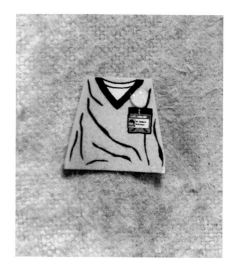

3. Using the tweezers, dip the decal into the distilled water. Dip the decal; do NOT soak or hold the decal under the distilled water for any extended period.

4. Allow the decal to sit for 60 seconds to allow the distilled water to release the decal glue.

5. While the decal glue is being solublized by the distilled water, apply some distilled water to the application surface with either the Q-tip or paintbrush.

6. Gently slide the decal from the paper backing onto the wet application surface.

7. Position the decal into its final location with a wet cotton swab. Gently roll the cotton swab over the surface of the decal to remove any trapped air bubbles as these can detract from your finished figure. If the decal shifts slightly during this stage, reposition and allow the decal and torso to sit and dry untouched.

8. Once your decal has completely dried, protect it by applying a clear coat of clear spray paint or hobby paint such as Krylon Crystal Clear or Model Master's Clear Acryl. The Model Masters will have to be applied with a brush or airbrush. Recall that the ink is merely resting on the surface of the film, this protective layer helps protect the decal from scratches.

9. Reassemble your custom minifig once everything is completely dry.

Basic application is pretty simple: the keys are quality purified water and removal of all air trapped below the decal. Any trapped air can create a problem referred to as silvering. The trapped air creates a space between the decal and the figure's surface. When light hits this space, it reflects and creates a silver or reflective appearance. This will detract from your finished figure, so do your best to remove all the air. If you find you just can't remove it, then it is time to start using the solutions used in advanced applications. These are designed to drive all air out from under the decal surface and alleviate this specific issue.

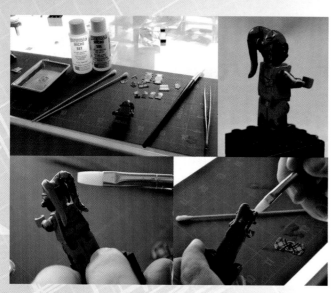

Decal application kits in use. Work area is in top left with decal application kit. Application of decal softening solution is shown in the bottom two images and the final figure is shown in the top right image. (To see the complete application of the decals used in Figure 1 check this Flickr set: www. flickr. com/photos/kaminoan/ sets/72157605952528360) Custom headpiece by Bluce "Arealight" Hsu. – Photos by Jared and Amber Burks.

With an understanding of the basic instructions, you have the foundation for the advanced instructions. The basic is great for decaling torsos and heads; however, it can get much more difficult when you attempt helmets, shoulders, and custom parts. This is because flat surfaces are pretty easy. Complex curves get much more difficult and require solutions to help the film conform to the curved surface.

The basic application is the same for the advanced or basic techniques (summarized below).

1. Completely disassemble the minifigure.

2. Remove any printing on the parts using Brasso that you wish to decal. Wash the figure parts to remove any residual abrasive.

3. Trim the decal with scissors.

4. Using the tweezers, dip the decal into the distilled water.

5. Allow the decal to sit for 60 seconds to allow the decal glue to release the backing paper.

6. During the 60-second interval, apply water to the application surface with a cotton swab.

7. Gently slide the decal from the paper backing onto the wet application surface.

8. Position the decal into place with a wet cotton swab.

9. Gently roll a moist cotton swab over the surface of the decal to remove any trapped air bubbles and excess water. If the decal shifts slightly during this stage, reposition and allow the decal and torso to sit and dry untouched.

Advanced decal application starts with using a chemical kit to improve the adhesion and contouring of decals to complex curves. These kits help make the decal crystal clear when applied properly, thus making the design appear painted or directly printed on the figure parts. Kits can be found at many hobby stores or online (Micromark www. micromark. com). If you are from a foreign country, you will have to find these application kits in your country as they contain a mild acid that cannot be shipped internationally. I recommend two kits, Badger and Microscale, both of which contain the two key solutions: decal setting solution and decal softening solution. The critical solution is the softening solution, so don't skip this one. The homespun alternative to decal softening solution is white vinegar; use it as described below for the softening solution.

Advanced Waterslide Decal Application Instructions

Step One: Setting the decal

After following the basic instructions above, apply decal setting solution with a paint brush

to the decal and let dry. Decal setting solution strengthens the bond between the decal and the part surface. It also helps remove any trapped air.

Step Two: Softening the decal

Decal softening solution makes the non-printed areas of the decal more transparent, giving the part the appearance of a directly printed design and it allows the decal to conform to complex surfaces. Using a soft brush, gently apply Decal Softening (solvent) Solution to the surface of the decal. Do not touch the decal until the solution has completely dried as the decal is **VERY FRAGILE** at this step. Repeat the application of the Decal Softening Solution until the decal has fully conformed to the surface and all air is removed from under it. Be sure to allow the solution to completely dry between applications; otherwise, you may damage or wrinkle the decal while it is soft.

Step Three: Protecting your new figure – Application of a clear top coat

Next, apply a clear top coat to the decaled area and decal edges to protect the decal. Clear gloss hobby paint works well. Hobbyists have been known to use quite a variety for overcoats including nail polish (which yellows in sunlight, so I don't recommend), Future's floor wax (sworn by many model makers www. swannysmodels. com/TheCompleteFuture. html), spray paint, airbrush paint, and brush on overcoats. I prefer Badger overcoats, which I apply with a water-moistened paintbrush, and Testors' clear gloss spray lacquer. Both work well and are easy to use.

Tips and Tricks for Application

There are several tricks that can be used at every step of the basic and advanced decal application, so be sure to read the following and think about where to use them above.

Cotton Swab:

The power of the cotton swab has been mentioned, but I really can't stress this tip enough. The cotton swab, especially the wooden stick version, is the best tool to apply decals (see figure 2). Use a very wet cotton swab when positioning the decal. However, a slightly damp swab is called for when removing trapped air bubbles and to absorb excess water. A completely dry swab is never recommended as it can stick to the decal. These wooden tips of these swabs are also useful to position the decal (See the hairdryer trick section below for more cotton swab uses).

Trimming/Strategic Cuts:

After you have read the advanced decal application and the use of decal softening solution you are likely asking, "Why do I need any type of cut strategy?" Well, through the use of strategic cuts, you can help the decal conform to curves and help remove the possibility of wrinkles in your decals.

Decal solutions.

Overcoat paints in gloss, satin, and flat finishes.

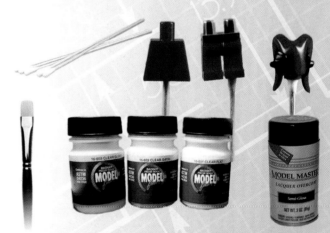

Tricks and tools of the trade. Upper left image is of wooden stick cotton swabs, upper right demonstrates using the wooden stick cotton swabs to hold parts, and lower panel images show common overcoat solutions and the soft bristled nylon application brushes. Custom headpiece by Bluce "Arealight" Hsu. – Photos by Jared and Amber Burks.

Trimming techniques used to cut out the decals are done in stages. Notice the internal cuts which allow the decal to wrap around the head tail of the custom part by Bluce "Arealight" Hsu.

Wrinkles can occur when using the softening solution, especially if you get impatient and try and help the decal conform to the part surface. While decaling a round surface with a gentle curve, make small slits in the edge of the decal once it is on the surface of the part. Do this with an X-acto knife or razor blade. Shoulders and shields are great examples of when this is helpful. This will allow the flat decal to curve and overlap slightly to take on the desired shape. This strategy can also be applied to the head tails in the advanced decal application example (see figure 3).

Softening Solution Alternative

As previously mentioned, white vinegar can be used in place of decal softening solution. Use 1 part vinegar to 3 parts water and then use this solution just as you would use decal softening solution.

If you are getting impatient for your decals to conform, you can also use a damp cotton swab to help the softening solution along, but honestly it is best to be patient. Whatever you do, DON'T use your finger as you will leave finger prints in your softened decal which will ultimately detract from your finished figure.

Hairdryer

If you are impatient, try a hairdryer. A hairdryer can be used at every decal application step including the basic steps to help speed evaporation. Just be careful to remove all trapped air bubbles before using it. This will also help the decal conform to a curved surface because of the heat. It is best to use it on low heat and low speed if possible. Never use a heat gun. Be sure to use something to hold the figure as you don't want to burn your hands. It might not seem hot initially, but the longer you hold the figure the hotter it will get. I find that sticking a cotton swab up one of the legs works great to hold a whole figure, but you can also do this with the torso or head. One other note, if you are going to use a hairdryer to help speed cure the clear overcoat, make sure you don't have any excess paint. If you do, it will dry in a puddle instead of spreading across the surface area. A puddle will look terrible and destroy all your hard work to this point.

Leg Application

When applying a decal to the minifigure leg, decal damage can occur if the leg is bent into the seated position after application. This is due to the torque applied to the leg, which presses the leg into the underside of the hips. As there is a ridge in this area, it scrapes the decal off the leg's surface. If this ridge is removed, or at least diminished, the odds of this type of damage occurring is reduced. This ridge can be removed by scraping it with a hobby knife from the inside of the leg area to the outside. Also, if you carefully place the leg in the up position, the leg is not pressed into the hip and damage is less likely. Use of the advanced application also helps as the decal more tightly bonds to the leg's surface, which means it rests lower and is hard to scratch off.

Trim areas on the legs for decals.

Have you ever run across that LEGO part that you just wished existed in another color? Unfortunately, LEGO cannot produce every part in a rainbow of colors. If you have wanted official elements in other colors, there are some easy ways to alter the element's color. This chapter will discuss paints, dyes, and a few more tricks to getting LEGO elements in a new color. Briefly, we will go through the different options for altering a part color; markers (Sharpie®), paints, fabric dyes, and vinyl dyes. The advanced method (vinyl dye) to alter part colors will require adult supervision, so please be sure to seek help if you are under the legal age to purchase this product.

There are limitations to some of the techniques that will be described, so if you are concerned over the final result or have never tried a specific technique, please use a practice part. This practice part could be anything from a like colored element to a duplicate part. Just be smart about your practice part, some elements are very expensive and/ or hard to find. If you can't use a duplicate part, use a like-colored element to work out your conditions.

Part Prep:

To begin altering any part color, the piece must be properly prepared to get the best color adjustment. Preparing the parts is required to remove residues on the elements from their production. To remove the residues, scrub each part with a mild dish soap and water. Using an old toothbrush to get into the small cracks and crevices will also help remove all the residues. The next step is to dry the part with a soft towel or wash cloth. To ensure the residues and water are completely removed, especially in the small crevices, wipe down the part with an alcohol wipe or 70% isopropanol (rubbing alcohol). The alcohol will evaporate quickly and help remove any water trapped in the crevices; it will also remove many non-water soluble residues. Now the part is ready for whatever alteration method you choose to use.

Sharpies:

Markers (paint or Sharpie) are typically only good for small color changes. Broad coverage is a challenge and they are not permanent regardless of what the manufacture states. These are best for quick coverage of small areas that will not see much wear. However, they can be used to alter part color for smaller parts and are likely the cheapest way to do so. If you use this method be sure to use even strokes across the part, and once dry, clear coat the part with acrylic paint to protect the ink. If you are after a temporary color alteration, this is your method of choice. Sharpie ink can easily be removed with a touch of rubbing alcohol, unless the alcohol-resistant version is used. The best use of a Sharpie marker I have seen was altering a light flesh minifigure head's color to yellow.

Star Wars Ewok figure with dark red cloak created using a red Sharpie marker. The eyes, cheeks, and hood pull strings were colored with a black Sharpie.

Paint:

Paint is the most widely used method to alter LEGO part colors. There are two types of paint, enamel and acrylic. Enamel is an oil-based paint that will dry slowly and requires paint thinner to clean up. Enamel can also have strong odors. If you are using it in any volume, be sure to take frequent fresh air breaks. Acrylic paints are water soluble, meaning they can be thinned and cleaned up with water, as long as they haven't completely dried. It is because of these two factors that I recommend acrylics.

When using paint, it is best to apply it in thin layers and build to the final finish. This will make a stronger finish overall and leave the least amount of buildup on the part. Buildup is the accumulation of paint on the part and when visible, it noticeably detracts from the final custom figure. It is better to apply three thin coats than one or two thick coats to an element to help avoid buildup (see the third blue head from the left in the paint vs. vinyl dye photo on page 31).

There are two basic ways to apply paint: with a bristle brush or an airbrush. If you have an airbrush, you likely already know it is a wonderful tool to apply paint to broad areas. Cheap airbrushes are all you really need, such as the ones that use small compressed cans of air. Slowly sweep across the part applying three sequential thin coats of paint. If you don't have an airbrush, however, adequate results can be achieved with a bristled paintbrush with a bit of patience and practice. I prefer nylon bristled brushes. Following the recommendation above and use several thin coats. Be sure to give each coat plenty of drying time before application of the next coat. Painting takes practice, so you might want to try a few test pieces before painting your rare LEGO element.

Paint does have flaws. Much like markers, it can wear or scratch off. It can also be hard to get perfect finish with a brush and, as mentioned before, you can get paint buildup. Minifig hands are very difficult to paint as it will almost always chip off if you routinely place anything in the figures hand. Because of these issues, many have sought out alternatives.

Dyes:

Dyes are more permanent color changes since they penetrate the surface of the LEGO elements. They do not build up on the surface making it impossible to chip off the part. However, they can be difficult to find and temperamental to use. As a result, there is no perfect solution to part color alteration. The two different dyes commonly used are RIT fabric dye and vinyl dye.

The RIT fabric dye website states, "RIT can be used to dye many different types of materials including wood, paper, plastic, feathers, and even canvas shoes!" RIT fabric dye can be used to alter the color of lighter elements to darker shades; however it cannot be used to lighten darker elements. RIT dyes can be mixed to create custom colors, making it a good alternative to paint if you need a darker element. Their website gives some guidelines for what colors can be obtained based on the starting color

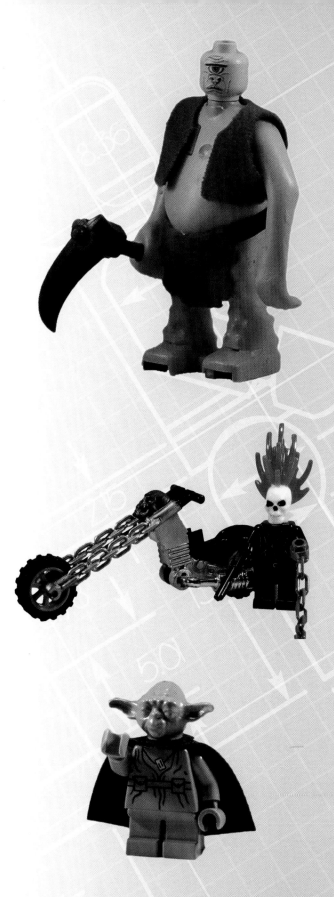

The Cyclops, originally a Harry Potter troll, received a full body color alteration using a custom mixed Testors' acrylic paint. Ghost Rider's motorcycle is painted silver and Yoda's head is painted with acrylic paint.

Mace Windu's purple lightsaber blade was colored using RIT fabric dye.

Grand Admiral Thrawn is sporting a custom colored head and set of hands. His blue color was produced using a custom mixed vinyl dye. This process can be expensive, but it gives the best and most durable results.

Helm visor part ready for vinyl dye application using an over the counter vinyl dye. – Photo by Anthony Sava

(www. ritdye. com/Questions. 50. lasso). Typically, it is best to experiment when using RIT dye. A trick I have learned is that it will penetrate into the part faster if the dye is warmed to near boiling temperatures. Just be careful, you don't want to melt your part! Also be sure to use a device (spoon) to help remove the parts from the dye. To begin, use an experimental part placed in warm dye and check for the desired color every 15-30 seconds. It is easy to go beyond the desired color, so frequent checking is best. Note the duration required to get the desired color and then dye your desired part for that duration. If you need to alter many parts to the same color, it is best to do so in small batches. Make sure to note the time and use fresh dye batches for each part to ensure consistent color.

Vinyl dye is a difficult product to find. Typically it can be found in automotive stores. Avoid the products called vinyl color (or colorant), which is easily confused with vinyl dye. An alternative to automotive stores is custom automotive paint shops. It is VERY expensive to purchase vinyl dye from these stores, but when you need the absolute correct color this is the only option. Typically this product comes in a spray can, so be sure to use several light misting applications instead of one thick and heavy spraying. Let each application dry completely before applying the next.

Vinyl dye contains strong organic compounds which help the dye penetrate the plastic; vinyl color (The product mentioned above that you don't want) is a fancy name for paint. If in doubt on which you have found, read the product components. One of the first compounds listed in vinyl dye should be acetone. Yes, we all know that acetone will melt LEGO elements when used in high concentrations, but in low concentrations it allows the dye to penetrate the LEGO element and alter the color, resulting in a permanent color alteration. There is no buildup on the surface; true vinyl dye cannot be scratched off. Because of the mechanism of action, vinyl dye must be applied above 70 degrees Fahrenheit and below 85 degrees F. If it isn't applied under these conditions the results are poor.

With many options for altering LEGO part colors you can create several new and different custom figures. Just remember, with all these options, it is best to figure out what works for the project at hand. If you need permanent hard wearing color alteration, look to your dyes, and if you need quick small area coverage look to paint or markers. Also, please consider if your custom figures are for display or hard play. Enjoy the new rainbow of colors now open to your LEGO elements and creations.

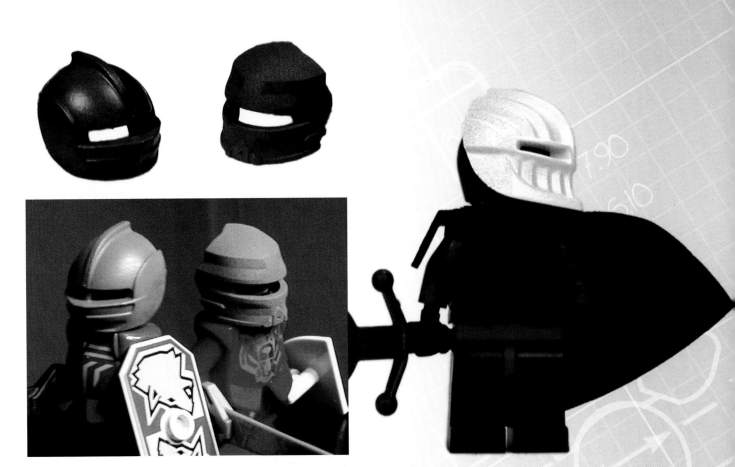

Temperature issues: notice the difference in the visors. The visor on the right was not applied at the recommended temperature, which resulted in a (lower quality) rough and dull finish. – Photo by Anthony Sava

White vinyl dye – Photo by Anthony Sava

V V P V P V P P

This is a comparison of paint (P) to vinyl dye (V). Notice that the color of the original part can have an effect on the final result; the 1st (originally yellow) and the 4th (originally white). Also notice the improper temperature application in the 2nd head and paint accumulation on the 3rd. The 5th head used a Testors' spray paint for plastics. The 6th head was colored using an over the counter vinyl dye. The final two minifig heads on the right were painted with an airbrush using Testors' paint.

It is time to learn how to accessorize that figure. There are many different types of minifigure accessories and several ways to create them. This chapter will primarily deal with creating new elements through modification. I know many think it sacrilegious to cut LEGO elements, but LEGO can't make everything for us. However, LEGO has given us a great foundation in parts and they tell us to use our imaginations, so let's do just that. I just ask that you not limit your imagination, get out that X-acto knife and pull out some LEGO elements; it really is okay to cut them!

This chapter deals with handling hobby knives, hobby saws, and razor blades; all of which are sharp. If you are a younger reader, please seek your parents' assistance in handling these items. If you are an older reader, please use care and caution; your fingers are not replaceable. Kevlar gloves are available to protect your fingers, I recommend these to all. They can be found in most woodworking/carving stores or online from hobby sites. I also recommend a non-slip cutting mat as well as good technique. The best lesson I have learned is to use sandpaper when possible as many items can be created by sanding; more on this in a moment.

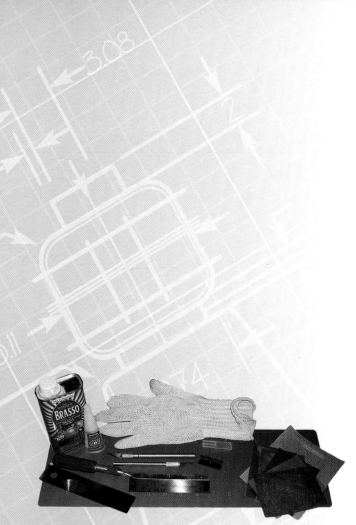

Tools of the Trade: Razor blades, hobby knives, hobby saws, sandpaper, Dremel tool (not pictured), cutting mats, Brasso, superglue, ruler, and protective equipment.

Proper Cutting Technique

1. Always use adequate lighting.

2. Never cut towards your fingers, always cut away to avoid blade slips (where the blade slips and can accidentally cut you).

3. Avoid holding parts in your hand while cutting. If you must hand hold a part to cut it, always wear a Kevlar glove.

4. If the part is thicker than 1/8 of an inch (minifigure handle thickness) use a hobby saw or Dremel® Tool. These are much safer when cutting through thicker materials.

5. Use a hobby cutting mat and a desk or table, never cut parts in your lap or on odd or uneven surfaces.

6. Only use sharp tools, dull tools can hang and cause slips and accidents more frequently than sharp tools.

The lessons in this chapter are going to be step-by-step examples presented in photos. Instead of trying to dictate how each item should be cut and/or sanded, the location of modifications will be noted and the manner of removing the excess material will be left up to you and your skill level. There are always multiple ways of altering parts. Honestly, most any accessory can be created using LEGO elements as a base: the only limitation is your imagination. Tips and pointers will be given through the instructional photos.

This lesson will begin with the creation of some basic minifigure scale hand weapons. While LEGO makes a few for us to use, variety—as we all know—is the spice of life. So we will begin with axes to equip our peasants. This is a simple and straightforward lesson,:merely make a cut and you have a new item. Quick, easy, and simple, yet effective, so let's get cutting.

Now that you have the basics of cutting down, let's take it a step further and add some glue in the mix by making a few custom swords, after all, our knights need new weapons to attack those well-armed peasants. These are merely a few examples, get creative and you can really make most any type of sword. In these first set of examples all you need to do is cut and glue, so work on straight and accurate cuts, as in the axe examples. If you do so there is nothing to clean up and your new accessory is ready for action.

Swords: *Top Left— Want to get a bit more complex and make a Bronze Age short sword? Follow the steps in image 2. Merely cut the tip of the sword and remove the guard. Now you can equip your Roman soldier with a Gladius.*

Top Right — This example displays a quick and simple way to alter an existing LEGO Sword to give your knights a slightly different weapon by merely flipping the guard. This is a basic first item to make. Cut off the guard and invert, reattaching with superglue. Concept by Emily Brownlow.

Axes: *Top — Just to show you that there are always multiple ways to make the same or similar items, check out this hand axe, which mixes a brown bar with a modified axe-head. Two-Tonic Knight is the resident blacksmith of modified LEGO weapons for Classic-Castle (www. brickshelf. com/cgi-bin/gallery. cgi?f=83128).*

Bottom —This example displays a quick and simple way to alter an existing LEGO halberd into a Hand Axe to give your peasants a fighting chance. Two simple cuts and you have a new weapon. Concepts by Emily Brownlow.

Are you more of a Star Wars fan? You can make your own sabre hilts. This is a bit more advanced so practice your cutting; everything needs to be straight and flush. You can always clean up a cut with sandpaper. Inspiration for this item was drawn from Deathstickman's work (www. brickshelf. com/cgi-bin/gallery. cgi?f=114500).

Well our knights are equipped, now our castle guard needs to be able to fend off the evil black knight. The classic weapons for this are long two handed style weapons, polearms, halberds, pikes, and spears. So let's take our new found skills and step them up just a bit with some precision cutting and in the last example, the naginata, some precision gluing.

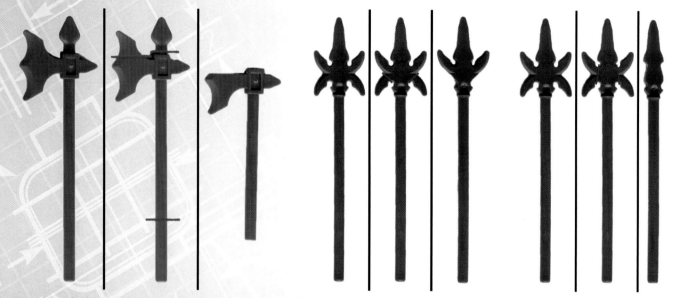

Two-handed Weapons: *In this example two precision cuts alter the LEGO pike into a different type of pike, so now we have a bit of variety (the removed pieces can also be useful so save them).*

2. Want to make a fancy spear? With 4 precise cuts you have a new spear. 3. Now let's make a large axe style halberd. With a few quick cuts you have one, just be careful or you can remove too much. It is always better to remove too little as additional cuts can be made.

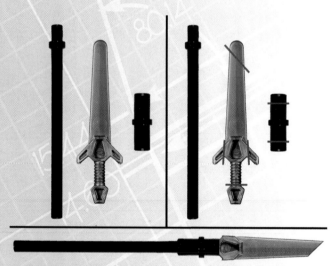

Well, you have small cutting down, let's get a bit complex and mix this together with some glue again and make a naginata. Just be careful here, I know it looks like the handle of the sword is removed but it is really inside the technic pin. Concepts by Emily Brownlow.

Accessories aren't limited to weapons. Want to make a new hat? Well, grab some sandpaper and let's get to it. Honestly, most of the items presented so far can be made with sandpaper. In the next example, no knives were used, just sandpaper, Brasso, and a small hand drill. The sandpaper is used to remove the top of the pith helmet to make it look like a floppy hat.

One of the greatest tricks in parts creation is the use of Brasso. No one likes those cut marks or rough areas left by sandpaper, we all like shiny bricks. Well, Brasso can do just that, restore shine (Micro-Mesh Sand paper system can also accomplish this task). After you have cut and/or sanded a LEGO element, take a rag with Brasso on it and rub the cut area until the "evidence" of the cut or sanding is removed, then wash the element. Now you have a new accessory that shows no signs of having ever been modified. After you have the hat shining, use the drill to

make two small indentations in the sides of the hat to allow the goggles to attach. LEGO really helps us out here, there are small lines that run down the side of the hat and they mark the perfect location for our small dimples. Using this drilling technique, one can add goggles or similar items to most any headgear.

Floppy hats: Here we make a floppy hat out of a pith helmet. Merely sand away the top of the helmet, but be careful not to sand all the way through the helmet; check frequently. After you have it close to where you want to stop, switch from sanding to Brasso, which will remove the sanding marks and return the modified LEGO element to a shiny state. Now take your hand drill (2) and make two small indentations on either side of the hat to allow the goggles to attach. Inspiration for this hat was taken from Dr Venkman of FBTB (www. brickshelf. com/cgi-bin/gallery. cgi?i=1486327). Want to take it to his level, heat up the brim of the hat in boiling water and give it a little flop with a pair of tweezers. To the right is a hand drill.

In the next examples on the right, we show that no parts are wasted when you start cutting. We demonstrate two different types of hat/hair combos and extreme cold gear. We will re-use the drill in this step so keep it close by. Here we will remove the lower portion of helmets to add hair and give the figure the appearance of his hair sticking out of the bottom, after all, not all knights or kings are clean-cut.

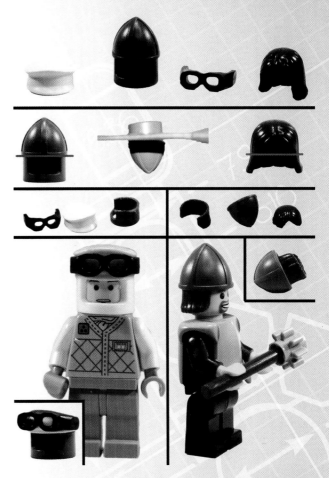

Hat Hair: The first example is a two-for-one. Using the four parts in the top panel we can make two unique hats, one for our friend to protect him from the cold elements and one to give him a bit more room for his hair. Merely follow the cutting lines to get the parts required. Make sure you clean them up a little before gluing any items together. To do this either use a bit of sandpaper or Brasso to remove the rough cut edges. In these examples I suggest using the razor saw as it will cut through this thicker element in a safer manner.

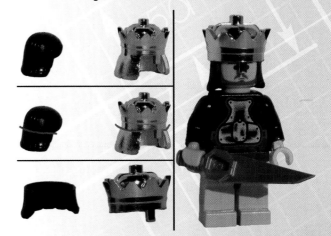

Just to show hair isn't just for helmets, but for crowns too, here is another example of what you can do with all this extra hair you have laying around. Inspiration for the hat/hair combo piece was taken from LEGOfreak of CC and MCN (www. brickshelf.com/cgi-bin/gallery.cgi?f=107540). Photo panel by Emily Brownlow.

35

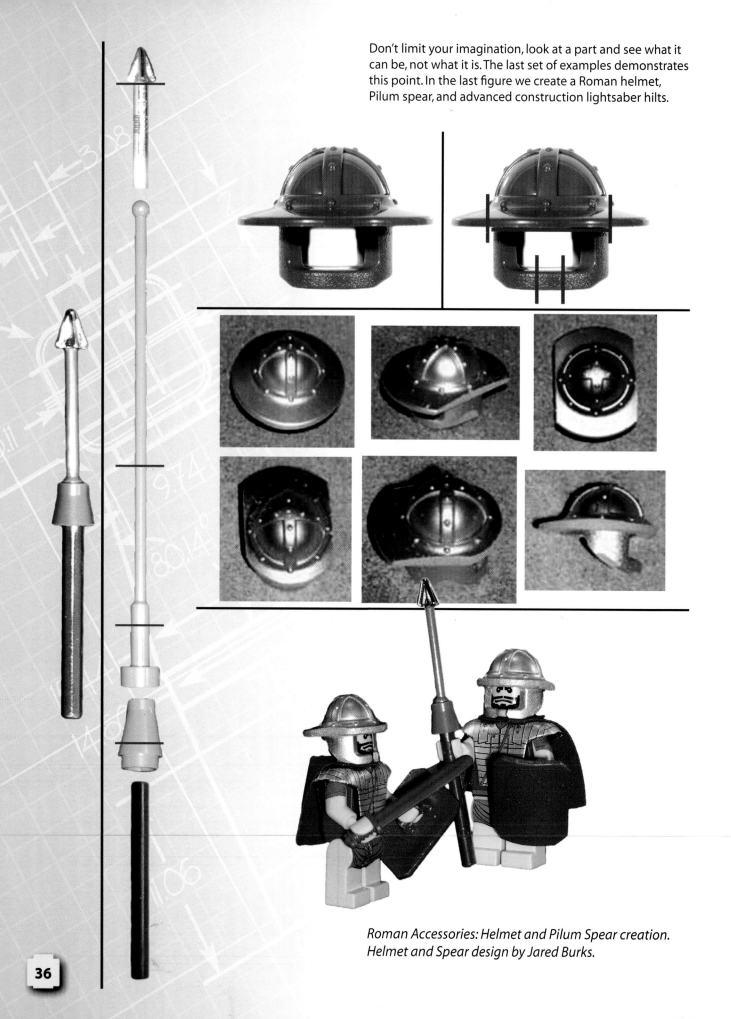

Don't limit your imagination, look at a part and see what it can be, not what it is. The last set of examples demonstrates this point. In the last figure we create a Roman helmet, Pilum spear, and advanced construction lightsaber hilts.

Roman Accessories: Helmet and Pilum Spear creation. Helmet and Spear design by Jared Burks.

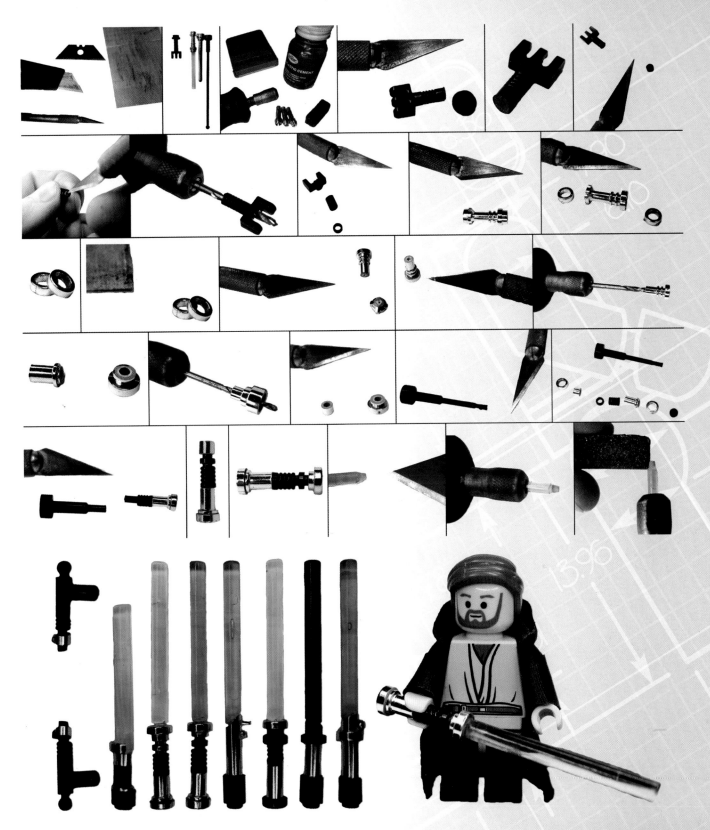

Advanced Lightsaber design and photos by Isaiah Childs.

Now that you know how to make many new weapons and a couple of new hats, get to work and let's see what you can make. Just remember: if there isn't an element made by LEGO that will give you just what you want, any plastic part from any toy, model, or whatever can be used. If you still can't find what you need, visit your local hobby shop and pick up some sheet styrene (sheet plastic). With this you really can create anything; it all just takes some practice.

Cloth: Left: Amazia sports the one accessory I never thought I would make: a pink fur vest. Right: Texas' Spirit Cheerleader is sporting a custom skirt designed by Mark Parker, photo and minifigure by Matthew Rhody.

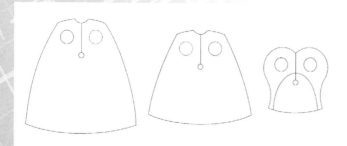

Templates: A cape (left), a short cape (center), and a pauldron (right), displayed above for your use. Additional templates are located at MCN (www. minifigcustomizationnetwork. com/templatecentral).

Frayed cloth, notice how the material unravels at the edges. Never throw away that frayed piece of cloth; it could be useful to make a custom figure sporting the worn look, just think about some of those tattered superhero capes. Photo by Mark Parker, used with permission.

Ever thought a minifigure needed a pink fur vest? How does one make a pink fur vest using paint or decals? I couldn't think of a way, so I turned to cloth. Honestly, I never thought I would need a pink fur vest, but alas, I was wrong. Cloth accessories can be anything from the simple LEGO-style cape to cheerleading skirts and everything in-between. It can take that customized minifigure to the next level.

The expert when it comes to cloth is Mark Parker (MMCB, www. mmcbcapes. servaus. net). Whenever I need cloth, I turn to Mark. That said, I have learned a thing or two and can take you through the basics. Before we begin discussing the different types of materials, designs, and tools we need, let us look at some of the cloth LEGO offers us. LEGO offers the cape, short cape, ponchos and the pauldron. Recently, LEGO released a skirt in the minifigure Series III collection with the hula dancer (which was different from the online photos). Maybe your needs are simple and you would like it in a new color, or with slight modifications. To the left are three templates made from the LEGO cloth. This gives us something to work with.

Now that you have a few templates, let's discuss materials. What can you make a cloth accessory out of and get good results? Well, you can use a piece of LEGO cloth (Cape or Sail [don't throw things — it is merely a suggestion!]), paper, fabric (printable or regular), or even leather. All of these are good options and fairly easy to work with if you are patient. Let's say you are using a LEGO cape, it can be easily modified into a short cape or pauldron using a pair of scissors. This is likely the easiest custom cloth piece to make as LEGO has already treated the material so it won't fray. Fraying is the unraveling of the material at the edges; even LEGO cloth will fray if played with enough.

Want to go beyond the basics? Well as Fryslayer (MCN and Classic Castle; www. brickshelf. com/cgi-bin/gallery. cgi?m=Fryslayer) pointed out originally, you can even use paper and your printer. Print any design on paper in the shape of a cape (for this example). Make sure you print both sides and then trim out your accessory. Then cover both sides in clear packing tape or spray both sides with a couple of coats of clear spray paint. This will give your paper a bit more rigidity and a bit of a shine. Now you have a new accessory with items already lying around your house. Also try using matte photo paper with semi-gloss spray paint; you can give your paper accessory a completely different look with a matte finish. Want to see this idea ramped up; check out Kyle "Armothe" Peterson's (Brickforge) work (www. brickshelf. com/cgi-bin/gallery. cgi?m=armothe), where he uses paper to wrap the figure much like a doll to customize the figure.

Printable cloth is another option, which is readily available at hobby and fabric stores. This works much the same way

as paper with no need for tape. The advantage of printable cloth is you get to print the designs and the background color, so you can make your cloth part any color you want. Printable cloth is typically treated with an anti-fraying solution, but read the instructions that come with your package to make sure. If you need to add an anti-fray agent, stay tuned: those details will follow shortly. Customizers in the know favor the Jacquard's printable cloth brand, but most any brand will work. If you cannot find printable fabric locally, check online. Some brands of printable fabric only allow you to print on one side, so if you are wanting the cloth to be the same color on both sides you might have to pull out your hobby acrylic paints, which work well on most cloths, including LEGO cloth. If you want to make it all you can even make your own printable cloth, according to the HP website (Instructions: h71036. www7. hp. com/hho/cache/313-0-0-39-121. html).

The last two options are leather and broad cloth, the latter being similar to LEGO cloth. Leather is simple, merely cut out your shape in thin leather and you are done. Leather can add a texture to your figure as one side of the material can be polished and the other suede.

Broad cloth is a bit more difficult than leather. The main issue with cloth is fraying. You have to prevent fraying without making your cloth so thick that it does not work/bend/fold well. One of the issues is that if you are making a complex cloth accessory, it can become visibly thick and interfere with the arm or waist studs. There is no right or wrong way to stop fraying. It can be as simple as running a small bead of glue along the cut edge or as complex as painting the cloth with acrylic mediums. Try different things and see if they work. No matter what you apply to your cloth, it is going to have an instant stiffening effect. More on the anti-fraying solutions in a minute, just remember the more you apply, the stiffer your final piece will become.

Now that you have worked with the patterns that LEGO has given us and used the different materials, you are ready to make your own patterns to create completely new cloth items. Try starting with a piece of paper and a ruler. Draw out the shape you are after and figure out how to connect it to the minifigure. Will you use the neck stud, the armholes, the leg studs, or all three? These are all options and Mark has figured out most of them, so you might look at his work for inspiration. Whenever I am trying to make something new, instead of cutting up my treated fabric, I draw it out on paper and cut up paper. I refine the pattern and then transfer it to cloth.

The most important tool for this work is a sharp pair of scissors. If you are a younger reader ask for help from your parents. I recommend Fiskas' brand scissors, which are a bit more expensive, but are worth every penny. If you want to get techie and are planning to make a lot of cloth, get a set of punches to more accurately cut your neck and arm holes in your cloth. An inexpensive alternative is a leather punch tool with a rotating punch size (see the toolbox chapter, page 13).

Paper: Armothe (www. brickforge. com/) makes complete custom figures with nothing more than paper, by wrapping the figure in a design. Notice the flat design, with neck and armholes on the left and the figure wearing it on the right. Photo and figure by Kyle "Armothe" Peterson

Printable cloth (left) compared to an official LEGO cape (right). Photo by Chris Campbell.

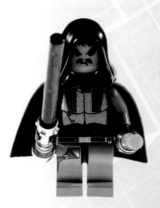

Leather is also useful to make accessories, as seen on this minifigure. Very sharp scissors are needed in trimming out this type of material.

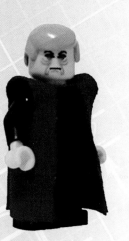

Notice the areas where the cloth pieces on this figure attach to the figure. If the anti-fray treatment causes the thickening of the cloth, attachment to the figure can be difficult.

Mark's templates make sure he gets the high precision required to make these types of accessories. Photos and minifigure by Mark Parker.

Here are some tips from Mark Parker about anti-fraying:

There are a number of different methods and products you can use to stop your cloth from fraying. These range from diluted White (PVA – Elmer's) Glue to Acrylic Medium or even artists Acrylic Varnish. Treating a small swatch of cloth is typically easier than a large piece; just make sure it is big enough to get a few pieces out of (around 15cm by 25cm). Both the PVA glue and the acrylic medium can go milky on some fabrics, especially dark colored fabric. Try using artist's Acrylic Varnish, which is very easily applied with a small hobby roller and doesn't require any thinning. One major advantage of using the varnish is that you can paint it on any colored fabric and it will dry clear. So if you are able to get cloth that matches the LEGO color you want, it can easily be treated with the varnish, which can then be used to cut out your design. Another good thing about the varnish is that you can actually mix it with acrylic paints to both color and stiffen your cloth. This trick works great for unusual colors! Just make sure you follow the directions on the bottle. I also find it easier to work on a clean, glazed tile. This provides a firm surface to work on, and neither glue nor varnish will adhere to it.

As this chapter began, don't limit your figures to wearing mere capes and pauldrons, dress up those figures in true Jedi Robes, skirts, and even ponchos. Some things just don't look right when only done with decals. Give your minifigures that extra dimension of realism. I know the purists are cringing in the corner at the moment, but LEGO has set the example for all of this customization, just check out the Star Wars Geonosian's plastic/vinyl wings, Harry Potter Troll's vest and loin cloth or the Deatheater's cloak, and the abundance of cloth in the new Collectible Minifigure Series. If you want to get really extreme ,check several of the Belville sets. Don't think these concepts can translate into a cool figure, just check some of the examples below.

Also remember that cloth isn't limited to minifigures: you can make flags, banners, sails, and even animal accessories, using the techniques outlined above. Just get creative, make new items and really customize your figures to the extent you can.

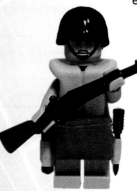

Advanced Cloth: *Here are some examples of advanced cloth accessories made by Mark Parker (Paratrooper and Vest) and Victor "Unknown Artist" Sobolev (Jedi Robes). Photos by their respective creators.*

Everyone wants that one desired part to complete their special custom figure. The easiest way to get that part is to sculpt it using clay. This chapter will present all the tricks and tips I have learned while making clay parts, but the best piece of advice I can offer is to simply sculpt. Practice improves any skill: if you aren't happy with your first attempt, try again. I sculpted the piece for this chapter twice, and honestly would like a third attempt, but time didn't permit. I have learned much about sculpting from many including; Isaac "Red Bean" Yue, Robert "Tothiro" Martin, and Bluce "Arealight" Shu. I have compiled what I have learned from these gentlemen as well as others and what I have taught myself in this chapter.

The Basics

First, you must use the proper clay for the job: the clay must be strong yet easy to work with and cure solid. However, please note that any part created in clay will be for display and light play only. There are ways to mold the sculpted clay part in silicon rubber and cast in resin plastics, resulting in a durable piece, however this is a bit complicated and a topic for a later chapter. To begin, you must create something to mold. If you are going down that road, let's start with creating a new part.

You must choose a type of clay to use. There are several types ranging from the earthen clay dug from the ground to completely synthetic. The major types of clay are Earthen, Nylon-reinforced, Plasticine, Polymer, Wax-based, and Paper-based, each having a primary use based on its composition. This hobby most often utilizes polymer clay, however, it ultimately boils down to what you are comfortable using. I do recommend clay that cures by some mechanism other than firing; non-drying and firing clays are inadequate for this hobby as they remain soft or require kilns. Clays can cure by alternate means than firing, including air and low temperature (oven temp). Some sculptors prefer using another type of media, Epoxy putty (MagicSculp), which cures at room temperature by chemical means yet retains many of the characteristics of clay. The major limitation of epoxy putty is its quick cure time, so you will need to sculpt quickly.

Polymer clay is the most commonly used clay in this hobby because it cures at relatively low temperature and remains pliable until cured. Polymer clay hardens by curing at temperatures created in a typical home oven, generally at 265 to 275 °F (129 to 135 °C) for 15 minutes per ¼ inch (6 mm) of thickness and does not shrink or change texture during the process. The curing temperature can be lowered if the clay is baked for a longer duration. You can also cure polymer clay by placing it in near boiling water or surface cure it using a hairdryer. Surface curing will allow you to sand your part; however without a complete curing, the clay will be fragile. When properly cured, polymer clays are quite strong and won't normally break when stressed or dropped. Polymer clay is sold in hobby and craft stores,

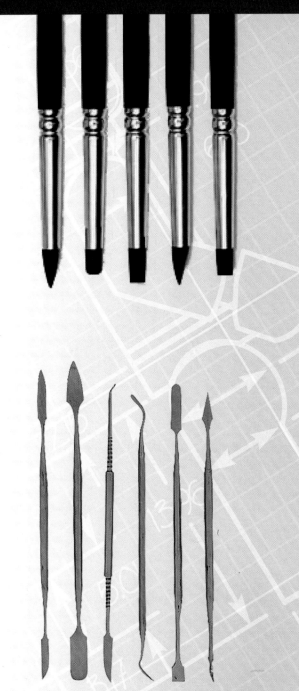

Several commercial clay tools. At top, there are rubber-tipped clay tools, and at the bottom are dental tools that can be used for shaping clay.

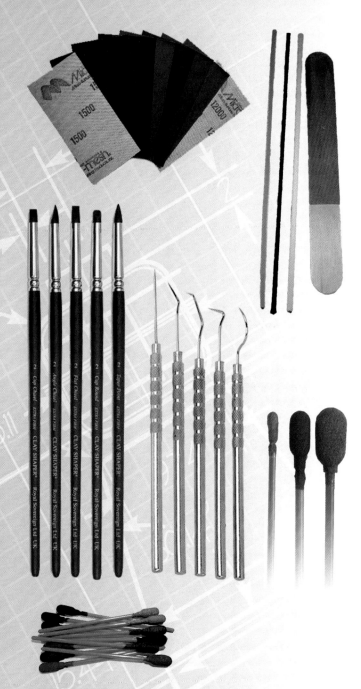

Several commercial clay tools as well a few makeshift sanding sticks on the upper right.

and even found in Wal-mart. Leading brands of polymer clay include Premo, Fimo, Kato Polyclay, and Sculpey. These clays are available in a wide array of colors so you might not even need to paint the parts you create. On top of these great options, this type of clay is quite inexpensive; a small package of clay, more than enough to create many parts, can be purchased for less than $2.

Once you get your hands on clay, play with it, work it, and get a general feel for it. Your hands will be your best tools to create your custom parts. However, you will need some additional tools to create the fine details on your creations. I find any fine-tipped item works well including X-acto knives, paper clips, and most any other small item. Find items that work for you. Your tools don't have to be store bought clay tools; most of these are actually too large for this work. If you want buy a tool set, look for dental tools. Remember this is very small-scale work; your tools need to be able to create fine detail. Your greatest tool is going to be sandpaper, but we will cover this a bit later.

Sculpting 101

Clay sculpture is generally created by one of two methods, addition or subtraction of material. These techniques are as they sound; either the addition or removal of material to create detail. I started in woodcarving, a subtractive technique, and commonly find myself reverting to this method. Find the technique that works best for you. One tip I can offer is that subtraction works better with surface cured clay. This can be achieved by using a hairdryer or near boiling water as previously mentioned. Note that the amount of time required to surface cure varies (based on your location, humidity, etc,)so be sure to experiment. Unfortunately, I cannot tell you exactly how to sculpt a part, — it will take time and practice to master this art. I can offer a few tips and tricks that I have learned and been taught by others to help speed your learning curve into this new avenue of minifigure customization.

While I am a subtractive sculptor, generally speaking, I still try and create my parts in layers. This allows me to sculpt and sand as I go, so when I am finished sculpting I have little sanding left. The layered sculpting method is demonstrated in on the top of page 43. If you try and sand the part at the end, you may find that the detail work on the piece is difficult to work around. Sanding is a slow process, but it is CRITICAL to making your custom element look more like LEGO elements. One tip to save time on your sanding is right before you cure (surface or complete) any part, give the part a quick wipedown with a cotton swab that has been dipped in rubbing alcohol (70% Isopropanol, 95% ethanol or higher is better, but hard to find). This will remove any fingerprints or other slight imperfections on the sculpted part leaving a smoother surface. To sand your custom parts you will need very fine grit sandpaper, which can be purchased at most hobby stores (woodworking grades are just too coarse). Check out the Micro-mesh mentioned in the toolbox chapter (page 11). Because you are using an ultra-fine grit paper, sanding will be slow, but you will be rewarded in the end with a better looking piece.

Queen's Headdress Layered Sculpture. The process used to incrementally create the queen's headdress. Notice the small additions at each step.

As with the tools you are using to sculpt the part you will need small tools to sand it. To make these sanding tools cut the sandpaper and attach it to small sticks or rods (popsicle stick, as seen on page 42). Make sure to step up in grit values to really get the best finish.

Tips and Tricks

Depending on what you are creating, especially if the item is long and thin (swords, etc), your creation will need an internal support skeleton. The support can be made of most anything. I have used everything from wire to wood but prefer styrene. Styrene is a type of plastic which can be purchased in sheets and a variety of shapes from most hobby stores. By using an internal support skeleton, your item will be stronger. The reason I prefer styrene is it has a slightly higher melting temperature than the curing temperature of polymer clay. This doesn't mean you can merely pop items containing styrene in the oven. However, the styrene is reasonably stable when the polymer clay is cured by boiling, hairdryer, or extended-time low temperature curing methods. Styrene/plastic can be incorporated into your sculpture as well. Certain shapes are very difficult to sculpt perfectly. Take the orb at the top of the head piece shown above. This would have been very difficult to sculpt perfectly, however by cutting the tip off a LEGO antenna a perfect orb can be added to the sculpture and when painted, no one is the wiser to how you did it. Another tip is if you are creating pieces with a grip (sword hilt, for example): make the grip portion out of plastic. This will help make your part more durable as the plastic will take the abuse of the part removal from the figure's hand, protecting the clay.

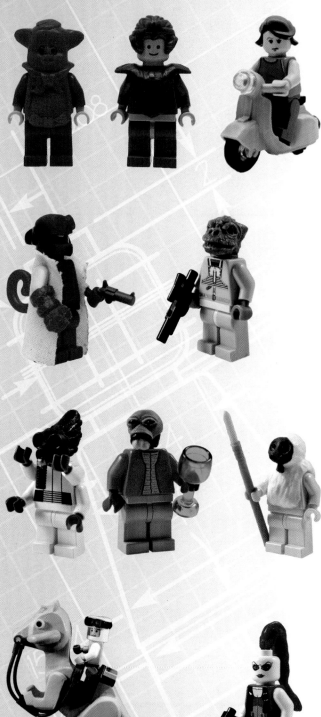

If you are creating a hairpiece or some other accessory item that must attach to a LEGO element, you will likely want to remove it after you have finished sculpting it. Removal can be tricky if your clay hasn't completely cured. Removal of incompletely cured clay can also result in damage to your creation. To help with part removal, you can wrap the LEGO element it attaches to with very thin aluminum foil or parafilm. Parafilm is a stretchable wax-like product that is used by hobbyists when painting models. It can be found at hobby shops or online. Another great trick is to sculpt over the top of another element. You can sand down a LEGO hair piece to a "skullcap" and add clay to the top of it allowing you to sculpt a new hair style, helmet or whatever. Most importantly this allows you to keep the internal stud acceptor and more easily remove the cured part. Just remember the plastic is present when curing parts created in this manner. They will need to be cured at slower/lower temperature, (layered sculpting page 43).

The final tip/trick I have for you is the use of clay sealants and air-drying glazes. The sealant is sold with most resin casting kits and the glaze is found with most clays. Both the sealant and glaze strengthen the cured clay and give it a finished sheen. This finish allows the paint a better surface to stick to and results in a finish closer to plastic. If you want to jump in and paint it, I suggest acrylic paints. They are easy to find and clean up.

The Wrap

This chapter will end as it began it; sculpt, sculpt, and sculpt. Only through practice will you get better. Sculpting and re-sculpting a piece will teach you something each time you make a design. Everyone needs a hairdryer, even if you are bald. Sandpaper is your friend: sand early and often, always increasing in grit. Seal your final part to give it that LEGO sheen. Finally, check out some of the great items created in clay below for inspiration.

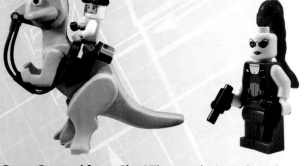

Parts Created from Clay! *These techniques have been used by others. Here are creations from Bluce "Arealight" Shu (Pig, Monkey King, & Scooter - top row), Robert "Tothiro" Martin (Hellboy, Star Wars Bossk, Nabrun Lieds, Ponda Baba, & Talz - second and third row), and Jared Burks (Tauntaun, Aurra Sing, Cad Bane, Shaak Ti, and Mohawk, last row, left to right).*

A previous chapter has addressed LEGO element modification, but those tips were simple cut and paste techniques to spark your thought process and to get you to think outside the box. Please review that chapter (page 32) for the basic techniques. Just to reassure those that believe it is sacrilegious to cut LEGO elements, let's examine the meaning of the word LEGO in Latin, which means "I assemble." So let's assemble a new element by cutting, gluing, and adding to a LEGO element to create something new. Use your imagination, pull out some LEGO elements, and get to hacking them apart!

In this chapter we will be handling hobby knifes, razor blades, and rotary tools — all of which are sharp. If you are a younger reader, please seek your parents' assistance in handling these items. If you are an older reader, please use care and caution: your fingers are not replaceable. Kevlar gloves are available to protect your fingers and I recommend these to all. They can be found in most woodworking/carving stores or online from hobby sites. I also recommend a non-slip cutting mat as well as good safety technique. The best lesson I have learned, after many trips to the ER for stitches, is to use sandpaper when possible as many items can be created by sanding, which is safer for your fingers. Please review proper cutting technique in the earlier modification chapter (page 32)

This chapter will demonstrate advanced modification techniques through the creation of a head piece for a Hawkgirl minifigure inspired by the DC character. The creation of this part is going to demonstrate several techniques that you have learned over the last few chapters. Briefly, we will start with a LEGO hairpiece, add a stud to attach wings, cut down the top of the hair, add styrene supports for creation of a mask, and using the supports and clay create a mask on top of the hair piece (We are adding the stud since the back bracket will not fit with the hairpiece chosen for the project). After the initial part is created it could be molded and cast using the information in later chapters to create a durable plastic version.

When creating a new element like this, it is important to think out the steps required in its creation. For example, if you started by sculpting the clay mask it could be damaged by the rotary tool when attaching the stud for the wings. For this part we are going to follow the steps below:

Creation Steps:

1. Rotary cut a circular flat spot on the back of the hair element.

2. Trim down a 1x1 round plate to the stud.

3. Fit the stud to the flat spot in the back of the hair.

4. Glue the stud in place with plastic weld glue.

5. Map out mask region on top of the hairpiece.

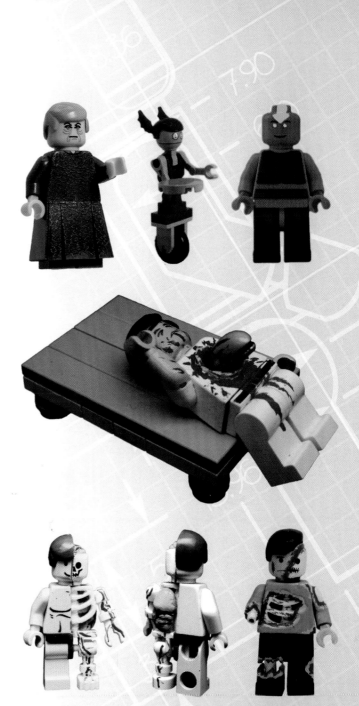

Advanced Modification: *Palpatine Skirt, WA7 by Jared Burks (top left and middle), Aang lit by Rob "Brickmodder" Hendrix, decals by Jared Burks (top right); Aliens, Skeleton, and Zombie by Kris Buchan (middle and bottom row).*

Step 1: *This diagram displays the starting element, the trimming of the 1x1 stud, the rotary tool bit used to create the flat spot on the back of the hair, the region the bit was used, the glue used, and the stud glued into place.*

Step 2: *This diagram displays the progression of marking off the hair for the mask, removal of the area, wing supports cut from styrene and attached with plastic weld, and clay roughed out.*

6. Sand down the region to allow the clay some space.

7. Cut out styrene supports for wing portions of the helmet.

8. Glue supports to the head.

9. Cover in clay and shape the mask part.

10. Use hairdryer or hot water to cure clay.

11. Paint (or mold, cast, paint).

There are several types of glue available. When attaching the stud to the back, we will need a very strong bond. To get the best bond, use plastic welding glues (Plastruct Plastic Weld). These types of glues surface melt the plastic of the two parts and bond them together. It is CRITICAL to be careful when applying these glues to not damage the rest of the part. If you spill or misplace any plastic welding glue on other regions of the part, set it aside until the glue completely evaporates and then give it a few more minutes for the plastic to stabilize before continuing. Superglue could be used, but the strength will not be the same as that achieved when using plastic welding glue.

Now that we have the needed back stud to attach the wings (their creation will not be covered here) we need to modify the top of the head to make space for the mask. To start the area will be masked out with a marker to guide while the sanding. Use a rotary tool with a sanding attachment to remove as much material as possible without damaging the interior structure of the hair piece. By removing the excess hair the mask will be more properly proportioned. The removal could be done with a hobby knife, if this is what you choose please exercise extreme caution. The rotary tool will make short work of the region and is much safer with the sanding attachment.

Now that we have the part prepped for the addition of the mask we need to find some styrene. Sheet styrene in various thicknesses is found in hobby stores for model builders. We will use the styrene to cut out the basic shape of the mask wing. These will act as supports for the clay. As the front part of the mask will be too thin to hold styrene we are only adding it to the back of the mask. Styrene is an interesting item to work with; it doesn't need to be completely cut through. You can score the design and then bend the styrene and it will "pop" out. Once we have the basic shape cut out we can sand the two sides to make them identical. Attach the styrene to the head with the plastic weld glue.

With the styrene supports in place it is time to add clay to the head and sculpt out the basic shape of the mask. When you are satisfied with the shape you will need to cure the clay. If you recall from the sculpting chapter, there are multiple ways to cure polymer clay including baking, hot water, or hairdryers. As we have added clay to a LEGO element, we can't place it in an oven for fear of melting the LEGO element. Out of the remaining curing options I prefer the hairdryer, however you can use either the hairdryer or hot water. When using the hairdryer, use a lower heat

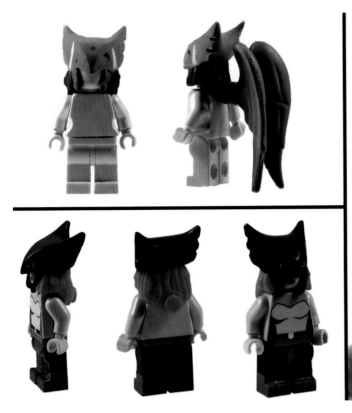

setting for a longer period rather than high heat for a shorter period. The higher the heat, the more risk to the LEGO element. Typically for a part like this (thickness) the clay will cure using a hairdryer in about 3-5 minutes. Once the clay is cured, you can use a metal file or hobby knife to clean and accurately add the slits to the edge of the mask wing. Also, to give the clay a smooth finish you need to sand the cured clay ultra smooth. A commercial grade sandpaper call Micro-mesh is great for this application. Micro-mesh sandpaper is a nine-step sanding process that will result in submicron scratches meaning that they are not visible to the human eye.

With the part constructed we are at a crossroads, either we paint the part or we mold and cast the part, then paint it. It is best not to paint before molding. From the painting chapter we know that acrylic paints are the easiest to use, quickly air dry, and clean up with water (see page 28). Now that we have the final painted part, it is time to use the other techniques to finish the figure. To create the wings refer to the chapter on sculpting (Chapter 6, page 41) and for the decal design and application please refer to those respective chapters (Chapter 5b, page 17 and Chapter 5d, page 21).

Now that you have seen how to integrate multiple techniques let's see what you can create. Where does your imagination take you? What will you LEGO "assemble?"

Step 3: *This diagram demonstrates the finished shape to the mask. The part was then molded and cast in orange colored resin, which was sanded and painted. Once painted, the eye decals were applied.*

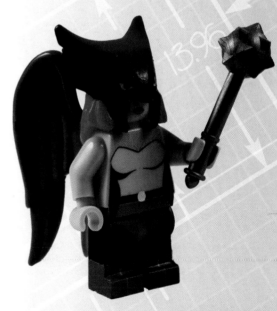

Hawkgirl Complete Figure

Prototype: Custom prototype element for molding created with sheet styrene.

Silicon Rubber Molds

Now that you have learned to make new parts, it is time to learn to mold and cast them in more durable materials. This section will present information on creating silicon rubber molds to replicate your custom-created elements. As you will be using chemicals in not only the creation but also the use of silicon rubber molds, please READ all safety information for all the products you use. The creation and use of silicon rubber molds by younger readers will require adult supervision.

The custom elements that you have created will now be referred to as prototype parts or prototypes. This is because they are one of a kind. As they are unique you may wish to replicate them or simply make them more durable. Silicon rubber molds are the best option to accomplish either of these means. There are many manufactures of silicon rubber for molding including; Smooth-On, Alumilite, MicroMark, and others too numerous to list. When making a silicon rubber mold two compounds, silicon rubber and catalyst, are mixed in a proper ratio to start a chemical reaction causing the silicon rubber to cure to a solid state. Many brands mix by a weight ratio, meaning a large amount of silicon mixed with a tiny amount of catalyst. These weight ratio mixes require the use of a gram scale to accurately recreate this complex mix ratio. However, the Smooth-On brand features a convenient 1:1 mix ratio, eliminating the need for very accurate weight measurements as they mix by volume.

Silicon Rubber Characteristics

Now that we understand the differences in mix ratios we need to discuss the differences in the many types of silicon products. These different types allow for the creation of molds with different features. Therefore it is important to understand what each type of silicon is for and it's weakness and strengths. There are four key features to understand about silicon mold rubber; elongation at break, tear strength, pot life, and demold time. The first two and last two characteristics are related.

Elongation at break is just as it sounds; how much will the silicon stretch before it breaks. This measure is typically presented as a percentage. A low percent stretch is about 250% and a high percent of stretch is 1000%. These percents are not arbitrary, low percent means the mold is more firm and high percent are less firm. Think of this like jelly versus Jell-O. Producing multiple part molds with a high percent stretch is very difficult as it will emphasize part lines in the mold. Part lines occur where multiple part molds meet. These are emphasized as the edges of the mold curl slightly due to the firmness issues. Tear strength is an indication of the force required to tear the rubber, it is measured in pounds per linear inch (pli). The higher the tear strength value the stronger the rubber. Typically higher tear strengths go hand in hand with greater elongation at break

percentages. So the same issues that plague multiple part molds with higher elongations at break do so with higher tear strengths silicons as well.

Pot life is the duration you have to mix the two reagents, silicon rubber and catalyst, together and pour the mixture into the mold box. The mold box is the container that holds your part while you are creating the mold. The shorter the pot life the faster the silicon starts to set. Typically 20-30 minute pot life silicon is preferred. This gives plenty of time to completely mix the silicon (which is key to achieving the proper elongation at break and tear strength) and to pour the silicon into the mold box in a **slow** and **controlled** manner. The demold time is the duration that it takes for the silicon to completely cure or set. It is important to wait this duration before disassembling the mold box and proceeding to the next step, be it molding a second part of the multiple part mold or using the mold to cast the a new part in resin.

Mold Design

Now that you have an understanding of the characteristics of the different types of silicon, we can begin a discussion of mold creation. I refer to this process as sculpting the mold and it takes almost as much creativity and effort as creating the prototype in the first place. A properly designed and executed mold will yield many great parts; a poorly designed and/or executed mold might not yield even one.

The first issue to consider when creating a mold is how the cast element will be removed. Typically, removal is the factor that determines how many parts to the mold you will have; one, two, or many. Once you have decided this issue the other key factors can be consider; mold box size, holding the prototype while pouring the silicon, part line locations, properly designed air vents and fill holes, and pour speed and technique. Mold boxes are easy; we already have a perfect product to create a mold box of any size, LEGO bricks. It is best to allow 3/16 to 1/2 inch (~1. 25 cm) or more of silicon to surround the prototype to give the mold the proper strength and rigidity. Therefore when laying out the mold box in LEGO bricks allow this much space around the prototype. Once your mold box is complete you need to measure its length, width, and height in centimeters (cm). When you multiple the three numbers together you will have a measurement in cubic centimeters which is equal to milliliters (mls). Milliliters is a volumetric measure, when you divide this number in 1/2 you will know how much of each part of the 2 part silicon to use.

The next issue is suspending the prototype in the box. Most molds for these types of prototypes are at least 2 parts. Therefore, the prototype will be suspended and the first half of the mold will be created, then the first half will retain the prototype while the second half of the mold is created. Typically the prototype is embedded in clay to retain it while the mold is poured. Not just any clay, but a non-drying clay like Klean Klay. When the prototype is embedded in Klean Klay this will create a part line, the line formed between the two halves of the mold. So place the clay along a line in the prototype to hide the part line so it

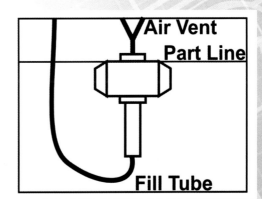

Mold Design: Proper planning includes sketching mold design to include part lines, air vents, and fill holes.

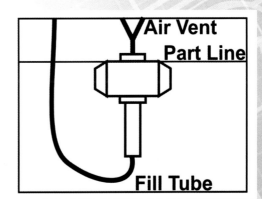Air Vent
Part Line
Fill Tube

Mold Box Part 1: *Mold box set up with Klean Klay used for part suspension and lock and key design for mold registration.*

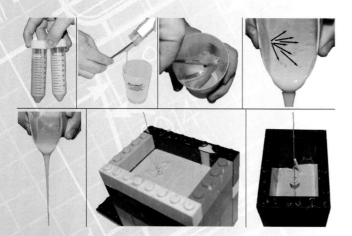

Pouring a Mold: Pour technique using the "V" shape and slow pour rate to remove air whipped into the silicon resulting from mixing the two parts together.

is less visible on the final cast element. Part lines on LEGO elements are visible under close scrutiny. The Klean Klay is also used to create keys in the two mold halves so they "lock" or register together. These are critical to proper mold alignment.

Properly designed air vents and fill holes for a mold are the most critical factors in creating a functional mold. Air vents and fill holes are where air trapped in the mold escapes as it is filled with the resin plastic. These need to be placed such that they can be trimmed and not affect the appearance of the finished cast element. Typically, the mold is filled from its lowest spot and vented from its highest. Designing good molds takes time and practice as well as 3-dimensional thinking. The way a prototype is held can affect the air vents and fill holes so consider this when embedding the prototype in Klean Klay. When I create a mold I use small diameter styrene rods to create the air vents and fill holes in the mold while it cures. When the mold has cured the rod is removed and the voids serve as vents and/or fill holes. Many suggest cutting these into the mold after it has been created, I do not recommend this as it creates irregular vents that can trap air. Air trapped in the part region of the mold when casting is the worst issue as it will result in a poorly created part.

Pouring the Mold

The final things to consider when pouring a mold is actually mixing and pouring the silicon for the mold. When mixing the two parts, pour part 1 and 2 into a mixing container (I prefer paper or plastic cups) in the proper ratio. Mixing with a metal or glass rod will reduce the amount of air introduced into the silicon, which is ideal. Many molding and casting kits come with broad wooden sticks; these will whip in more air, which could cause problems. When completely mixed pour the mixture into a new container and continue to mix. Properly mixed silicon is critical in yielding a mold with the elongation at break and tear strength indicated by the packaging. Improper mixing can result in weak spots in the mold and result in a short mold life or poor part production. A properly mixed and cared for mold should be able to produce 25-200 parts, depending on the type of silicon. Remember to keep an eye on the clock as the silicon will start to set as you approach the pot life duration and you have yet to pour the silicon into the mold box.

Once the silicon has been completely mixed, it is time to pour it into the mold box. Pour technique can help reduce air bubbles in your mold, which can weaken and reduce the mold's functional life. When pouring from a paper or plastic cup you can pinch the edge forcing it to form a V shape. Then when pouring very slowly in a thin stream any air bubbles in the silicon will pop. This is because the air bubbles are stretched as they fall out of the cup in a fine stream. Remember to allow $3/16$ to $\frac{1}{2}$ inch (~1.25 cm) or more of silicon on top and bottom of the part as well as to each of the sides.

If your prototype requires a multiple part mold be sure to coat the area where the first and second mold parts

meet with silicon-to-silicon mold release. If you do not, the two mold portions will bond and you will NOT be able to separate them from one another. With proper application of the mold release (silicon-to-silicon, but there are other types) the two parts will easily come apart allowing the prototype or cast element to be removed. When you are pouring the second part, exhibit care to not disturb or remove the prototype from the first half.

Following the above instructions, you will be able to easily create a mold of one of your custom sculpted elements. Two part water-thin plastic resins used in casting cure by an exothermic reaction (releasing heat). This heat slowly wears the mold. Be cautious not to cast too many elements at one time as you could lower the life of your mold. Let it cool between castings. To get the longest life from your mold, it should be stored in a cool, dry place. Happy Molding!

Casting

This section is packed with details on casting in resin plastics. With the information gained in the preceding section, we can address the concept of resin plastics. Recall the chapters on creating custom elements in clay (page 41) and element modifications (page 32). With the information in these chapters and the information below, you will be able to create, mold, and cast a custom element in durable resin plastic. As you will be using chemicals in not only the creation of these custom elements but also in the molding and casting stages please READ all safety information for all the products you use. The creation and use of resin plastic by younger readers will require adult supervision.

Resin Characteristics

Resin plastics are composed of two parts much like the silicon rubber. By mixing part A with part B an exothermic (heat generating) chemical reaction takes place curing the resin into a hard plastic. Most resins are a 1:1 mix, however a few are not, so read the instructions carefully for the resin you choose. I recommend the 1:1 mix for ease of use. Resin has a pot life, demold time, viscosity, tensile strength, and hardness, much like silicon rubber. These characteristics effect how long the resin will take to cure, how well it will flow in the mold, and how strong the final part will be.

Resins typically have a much shorter pot life and demold time than silicon rubbers. Because of this shortened duration resin must be quickly mixed and poured into a mold before it cures. If mixing takes too long the resin will start to cure and thicken keeping it from being pourable and thus, it won't enter the mold. Most resins are referred to as water thin; this is in reference to their viscosity. A low viscosity resin will pour very easily. This means the resin will more easily fill small voids in the mold. Tensile strength and hardness refer to the strength of properly mixed resin plastic. If the resin is improperly mixed or it contains bubbles, the strength will suffer. The hardness also indicates how durable your final part will be; keep this in mind if you intend to sand the final product or if it is intended for rough play.

I prefer resins with 3-5 minute pot lives, anything shorter is hard to properly mix and get into the mold. As with silicon

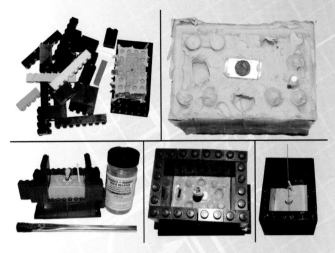

Part 2: *Disassemble the mold box for Klean Klay clean up. Reassemble the mold box. Coat the top with rubber to rubber mold release and pour the second half of the mold.*

Final Mold: The finished mold with original and replica cast parts.

be sure to mix thoroughly; this means mix in one cup and then transfer to a new cup to continue mixing. My rule of thumb for mixing time is one-third of the duration of the pot life. This gives you the other two-thirds of the pot life to pour the resin into the mold. Mix gently, but thoroughly, to avoid excess bubble formation. Also note improper mixing can also affect the cured resin color.

Coloring Resin

Most resins will turn white when cured, however, there are some that turn amber, clear, tan, opaque, or yellow. If you intend to color your resin you need to keep this characteristic in mind as it will affect the colors you can achieve. For example it is very difficult to achieve black colored resin when using white cure resin. When mixing the black pigments with the white cure resin the resin will turn light or dark grey depending on how much black pigment is added. One would have to use a clear or amber cure colored resin. White resins typically have a higher shine and greater strength, so I prefer to work with them. It is possible to work around the color issue mentioned above for most colors; however you must be careful of foaming.

Pigments and Foaming

When you mix too much pigment into a resin plastic you are adjusting the water content and plastic to hardener ratio of the resin. Most pigments are suspended in either water or oil. When adding a pigment, this added liquid volume can affect many of its properties, most importantly the foam point. When a resin contains too much moisture (from pigments or humidity) it will foam creating hundreds of bubbles in the resin as it cures. The exothermic (heating) reaction causes these bubbles to form, which will ruin the part. Use a small amount of resin and pigment to test the color you wish to make prior to pouring several parts or mixing large batches of colored resin. Start slowly and test the foaming point. Also test the demold time of the resin, as you add more pigment you will need to extended the duration you leave it in the mold.

Typically most companies offer pigments in the following colors: white, black, red, blue, yellow, green, and brown (primary and secondary colors). These colors must be mixed together to achieve the color you desire. Creating custom color recipes will take quite a bit of time, so make sure to take notes. This does not mean you will have perfect color matching or consistency. Day to day humidity changes and mixing variability will affect the final color.

Some pigments are available in a powder form, which is great from a foaming standpoint, but this makes them much more difficult to use. Measuring powders to determine the quantity to add to resin is difficult. Also powders have an ability to find their way into places they shouldn't. Remember these are VERY concentrated pigments so very little on your floor, clothes, or hands could result in a massive mess. If you choose to go this route be very careful and get a VERY accurate scale.

Foaming in the resin, and some end results.

Pigments.

Filling the Mold

One would think that filling the mold would be easy. However, there is a process that will extend the life of the mold and aid in casting. As previously mentioned, when the resin parts are mixed together an exothermic reaction occurs. This will ultimately destroy the mold, so take every precaution to protect and extend the life of the mold with each casting. First, the mold should be sprayed with mold release. I prefer Mann's Ease Release 200. This will help keep the silicon rubber from drying out due to the heat and thus extend the life of the mold. This will also keep the mold from sticking to the resin once cured. Spray the mold with a thin, even coating before each use and then use a dry paintbrush to gently brush over the mold to make sure every surface is evenly covered. Allow the mold to sit for 3-5 minutes for the release agent to dry. After casting it is also best to let the mold rest and cool, as the silicon will hold heat for some time. It is this heat over time that will destroy the mold. Immediate repeated castings can expedite the mold failure.

Release agent spray.

Pipettes and Mold Release

Once your release agent is dry, you have to determine how you are going to fill your mold. Many people employ the same thin stream method used when pouring the silicon. This will minimize bubble formation in the resin; however I prefer to use a plastic pipette. These are small plastic graduated tubes with a squeeze bulb on one end. This allows the user to uniformly push the resin into the mold. I find that this pressure helps to fill the mold very uniformly, if the mold is properly designed. This also avoids the mess of the thin stream pour and speeds the resin into the mold while still water-thin. However, because this is not a thin stream pouring we risk the addition of bubbles. This means we have to employ other techniques to remove or minimize the risk of bubbles.

Plastic pipettes.

Bubbles can be minimized by several methods including; tapping, vibration tables, extra fill volume, brushing the mold with resin, and new air/overflow tubes. Tapping is the simplest method to attempt to remove air from the mold, merely tap the mold on a solid surface in an attempt to drive any air bubbles up and into the air/overflow vents in the mold. This method can be stepped up by using a small vibrating massager. Merely touch the vibrating massager to the bottom of the mold and let the vibrations free the trapped air. Be careful, as both of these methods can splash resin out of the mold.

Using pipettes to pump resin.

Another method for eliminating air bubbles is to use a paintbrush and brush or pour some resin into trouble spots to ensure air cannot be trapped in these regions when the mold parts are assembled. This is particularly useful for small regions at the bottom of the mold. Be careful when using this method; keep an eye on the pot life of your resin. It may take longer to fill these areas, assemble the mold, and fill the main mold void before the resin cures.

All resin volumes slightly shrink when curing. This means if you completely fill the mold when you take it apart the resin will have pulled back into the mold slightly. If the air/

Prototype and Replicate Part.

overflow tubes are short, this shrinkage could pull air into your mold. This issue can be counteracted with the addition of some small straws or reservoirs in the air/overflow areas. The added weight and volume of extra resin will keep air out of the mold and fill it as the resin shrinks during curing. This issue can be avoided with proper mold creation.

When filling your molds, you might be confronted with a continual air trapping issue. This could be resolved by cutting a new air/overflow vent in your mold. This can be done with an X-acto knife; however I recommend a rotary tool with either a cutter or drill bit attached. Cut through the rubber mold slow, especially if it is a very elastic mold. This is one way to salvage a mold and make if functional. If you mess up and need to repair the mold remember that rubber will stick to rubber unless mold release is used. So you could fix any error by pouring new rubber into the error. Just remember you will need to fill the internal volume and any air/overflow tubes you wish to keep and also coat these areas with mold release.

The final way to avoid air bubbles is to understand why they form in the first place. Yes, it can be simply trapped air because of small areas, but they can also form in other areas for no apparent reasons. Most commonly they form in these areas because of surface imperfections in the custom part. These small imperfections allow a place for the bubble to form or rest. Through the use of better sanding technique of the part before the mold is created, these areas can be minimized and removed as a source of air bubble formation. So spend the extra time to completely sand the parts you wish to mold and cast.

Wrap-up

Now that you have the secrets to basic molding and casting let's see what you can create. Be sure to reread all the chapters as each will give small insights that can improve your work. This is a process and by cheating at any step you will sacrifice the results of the next. Enjoy making your own plastic parts.

As the sections on sculpting and modifying parts conclude, I hope you have been creating new elements and that you have developed an understanding of design/creation style. If you haven't developed a clear style, hopefully this chapter will help you define or refine your style. Perhaps you are a realist in your parts creation making them highly detailed — do you tend towards the cartoony style making them oversized, or do you attempt to stay close to the style of the LEGO Company? In this chapter, I am going to point out what I believe to be the best hand-created custom parts. By doing so, I hope to teach how to evaluate custom sculpted items as well as help you refine your style for creating custom elements.

Just as in the previous chapter on decal design, sculpting a custom part relies on interpretation of the inspirational object in the LEGO scale and form. You need to decide what parts of an inspirational item are essential for its identification in LEGO scale and form, and which are merely too detailed to recreate or might distract. Typically, this decision will rely on your skill level. You may start out creating very simple elements that are merely 3 dimensional shapes with little detail and as your skill develops you will be able to add more and more complexity to your work. Recall the method of layering when creating clay sculpture, as your skill develops you will find adding additional layers easier.

Simplicity

Certain items can be created in a very simple style, by using a simple style they gain an elegance. In my opinion, it's the simple design that is the hardest to create, but it is also the one most readily identified with the inspirational item. For example, Bluce "Arealight" Hsu has created a scooter inspired by a Vespa; notice that in Bluce's work he doesn't make anything bold, just a simple scooter with nice rounded proportions. He very wisely incorporates LEGO elements for the head and taillights, seat, and wheels. By incorporating the LEGO elements the custom item blends more readily into the LEGO environment. The greatest part of this creation is its symmetry, which likely gets discounted as many would only notice if it was incorrectly made asymmetric. This is one of my favorite custom items as it is "so LEGO" that an outsider to the customizing field probably could not tell it wasn't an official item.

Bluce carries this simple style into many of his custom items, including his tentacle head with accessory parts. He used the style of the basic LEGO head and merely attached tentacles to achieve his custom element. His head is completely minimalistic allowing the accessories to add the detail, primarily by addition of a second color to the head. The accessory items' details are also sparse, but contain enough detail along with the color to identify the head with the inspirational character. The concept and design of the tentacle head is "so LEGO," I believe LEGO has followed the hobby. If you examine Kranxx/Rench figures from the

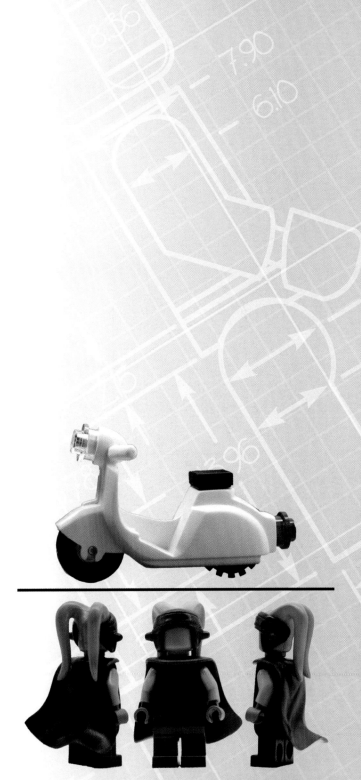

Bluce "Arealight" Hsu's scooter and head tentacle figure. Notice the simplicity to both designs and how well they both fit into the LEGO-verse.

LEGO's Kranxx/Rench head. These are official parts that speak to the heart of simple creations. The real genius is the mouth design.

new Space Police theme you will see that LEGO has created a head very similar in style to the tentacle head. They have added simple details to a basic LEGO head shape, the first in the official "LEGO-verse." LEGO does do something with this part that has never done before, which I consider quite brilliant. LEGO has left an open area for the mouth — because of the head's orientation paint on the neck stud, the open mouth has a painted interior and I don't believe the added detail cost them a penny more in production costs. This is smart, yet very simple sculpture design that takes advantage of production requirements.

Complexity

Some sculptors focus on details; these sculptors go well beyond the level of detail that LEGO would incorporate into a design. Examples of this type of work are created by Hazel-Tam of the Amazing Armory, Jason "Jasbrick" Burnett, and Nicholas "NickGreat" Sim. These sculptors see beyond the limitation of the size and push the envelope of what is possible to recreate in this scale.

Hazel's use of complex part design is simply amazing. He adds more complexity to his figures than any another sculptor out there as seen in the image on the left. Notice his modifications to the LEGO motorcycle where he creates a dirt bike. The frame is still the simple LEGO style, but he has added detail upon detail. Hazel has even gone to the extreme of adding a fill-in for when the rider is not on the bike to make it look even more real in the absence of the rider.

Jason and Nick are primarily known for their cut and glue approach to sculpt/create the desired part. In their application they are carvers rather than sculptors; carving away the undesired portions of plastic. This approach is very viable and a great way to start creating custom parts. Jason and Nick are masters at this technique, making it near impossible to find their joint work.

Hazel-Tam (dirtbike - top), Jason "Jasbrick" Burnett (fantasy figure – lower left), and Nicholas "NickGreat" Sim (Samurai lower right). These three sculptors create parts with extreme levels of detail.

While Jason is primarily known for his cut and glue I have chosen to show one of his clay works on the left. It is a figure inspired by the Stargate movie and TV series. Notice the level of detail; it is simply a stunning figure. This piece also demonstrates Jason's other impressive skill, his ability with a brush. His freehand painted figures are better than any other I have seen. His use of paint on this clay figure helps hide some of his clay errors, another wise tactic to use when learning to sculpt.

Nick is known for several of his figure series, but none are as well known as his Samurai series. In case you have missed them, one is shown in on the left. This is a cut and glue figure where Nick has created a custom helmet beyond any LEGO has produced, yet LEGO produced the parts. Nick has taken the LEGO samurai helmet and added the front face plate from the Spider-Man Green Goblin mask. He has removed all unneeded portions and managed to keep the plate perfectly aligned with the face. It is this vision that allows for the creation of such a phenomenal work. The figure is made all the better through the "complete" feeling obtained by adding all the accessories and keeping the style flowing through them. He utilizes LEGO elements and melds them together to create complex yet simple new figure that is beyond LEGO yet obtainable with its use and one that still fits in the LEGO-verse.

Sculpting Originators

Two sculptors in particular have struggled to create items that fit in the LEGO-verse. They are also the primary people who helped introduce clay part sculpting to the hobby. Robert "Tothiro" Martin was the first person that I am aware of to create custom elements for LEGO figures. His items still set the mark as what is possible. Notice the simple details, yet the elegance to his work to the right. This photo shows clay versions of several of his last works in progress. Robert's parts are still highly sought after even years after their introduction.

The second sculptor is no longer producing items any more, yet is also one of the field originators, Isaac "RedBean" Yue. Unfortunately I was only able to locate one of his clay items, which is shown in the image to the right. Notice the simple lines and the incorporation of LEGO elements. The key to this work is the symmetry. Speaking from experience this is the hardest thing to create. Making a perfectly symmetrical part by hand takes hours of work.

Rising Stars

The newcomers to the field of sculpting that I have had my eyes on are Jamie "Morgan19" Spencer and Kris "DrVenkman" Buchan. Both have started creating clay elements that are quite interesting. Their techniques are a bit rough, but steadily improving. The key that they have already figured out is practice. I see improvements in each of their items over the last. Jamie, like Jason, uses paint to help hide errors or make the errors part of the "texture" of the part. I look forward to great creations from both in the future.

Personal Note

I am still a relative newcomer to the field of sculpting and am refining my craft with each part I create. I have found that repetition is the key; I will sculpt the same part multiple times. I believe my best effort to date is my Cad Bane sculpt.

When viewing a custom element it is hard to realize how many hours went into its creation; the basic sculpting, the cautious curing of the clay, and the extensive sanding to perfect and repair the sculpting errors. Time accumulates and perfect sculpting cannot be rushed. Now that you have seen what is out there, remember we were all beginners at one time. Only through practice will you get better.

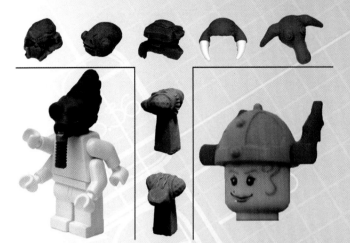

Robert "Tothiro" Martin (Star Wars Inspired parts - top) and Isaac "Redbean" Yue (helmet – bottom). Robert was the first person's sculpture I saw for the LEGO-verse. This is some of his last work. Redbean has primarily created weapons and armor. His parts skirt the line of the LEGO-verse yet still find a nice home. Unfortunately, I was only able to find a single photo of his clay work.

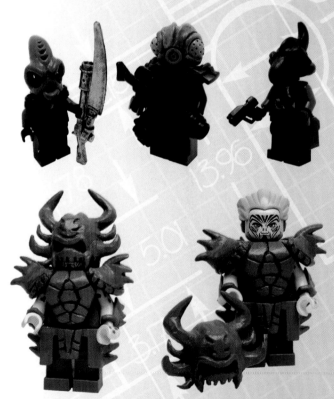

Newcomers to the field of sculpting Jamie "Morgan19" Spencer and Kris "DrVenkman" Buchan are showing great promise with their early work. The first 3 figures are Jamie's and the final 2 photos are Kris'.

Cad Bane. This is my best sculpting attempt to date. The hat and head were completely custom-created. The cloth jacket was generously given to me by Mark "MMCB" Parker.

This book has been primarily concerned with teaching how to create custom figures and all the accessories needed to outfit your figure. This isn't always practical and until recently (with the creation of the Collectible Minifigure Series) LEGO's accessories were fairly limited. So when you can't or don't want to create every part of the figure from scratch, it is time to look to the aftermarket of LEGO compatible accessories. This is actually quite a large field with about 15 main contributors beyond the LEGO clones: Bestlock, Cobi, Megablocks, and Oxford.

To begin this discussion please consider that many of the accessories created by the clone brick and action figure companies including: Bestlock, Cobi, Games Workshop, Hasbro, Medicom Kubrick, Megablock, Oxford, Sidan, Stikfas, and many others are very compatible with LEGO figures. Many customizers have used hats, weapons, capes, and other odd parts to complete a custom figure. One of

the easiest ways to make a LEGOized Star Wars Bouush Leia figure, for example, is to use the Hasbro action figure helmet over a LEGO head. This can be a very economical way to get the needed accessory, especially if you don't have the time to make it. Buy the action figure or, yes, one of the other companies' sets. I know many wouldn't touch their inferior bricks, but get over it if you need that accessory item (Also you can use those bricks to build your molding boxes with instead of destroying your LEGO bricks, so you can repurpose the bricks). Commonly many of these "other" companies' accessories are sold on eBay and a few, like Sidan, are readily available on Bricklink (www. bricklink. com/store. asp?p=Minifig. Cat). Several of these other companies have themes in line with LEGO and where they succeed, in my opinion, is more artistic accessories. Instead of a plain straight spear it might have detailing or be slight crooked. This detail could help make your custom figure unique.

Third-Party LEGO Compatible Manufacturers

Manufacturer	Owners	Web Address	Decals	Parts	Cloth	Mods
Amazing Armory	Hazel	bricklink. com/store. asp?p=AMAZING ARMORY		X		
Arealight	Bluce Hsu	Arealightcustoms.com		X		
BrickArms	Will Chapman	brickarms. com		X		
BrickForge	Kyle Peterson	brickforge. com		X		
Brickmodder/Lifelites	Rob Hendrix	brickmodder. net, www. lifelites. com				X
BrickTW	Kevin Chu	shop. bricktw. com		X		
Custom Brick & Minifig	Christo	myworld. ebay. com/christo7108		X	X	
Fine Clonier	Jared Burks	fineclonier. com	X	X		
Little Armory	Jeff Byrd	littlearmory. com		X		
MinifigCustomsIn3d	Andreas Holzer	shapeways. com/shops/MinifigCustomsIn3d		X		
MMCB	Mark Parker	mmcbcapes. servaus. net			X	
Roaglaan Stickers	Tim Fortney	roaglaanscustoms.com	X			
Saber Scorpion	Justin Tibbins	saber-scorpion. com	X			
The Little Arms Shop		thelittlearmsshop. com		X		
Unknown Artist Studio	Victor Sobolev	unknown-artist. com/product	X	X		

With knowledge of the LEGO clones and action figure market we turn to the third-party market: manufacturers that specifically create accessories that are compatible with LEGO figures. To summarize, I have created a table above of all the vendors, their speciality, and their store location. This is not an exhaustive list of where you can buy items, as many of these groups have distributors. To locate a distributor close to you, please check their websites or run a Google search for their names and you can find one in closer proximity to save on taxes and possible import fees. However, whenever possible I always try and buy directly from the manufacturer for the best service. Navigating these sites can be very time consuming, understanding your needs before visiting can be helpful and I suggest using search functions on the sites when possible.

Amazing Armory

Amazing Armory offers a line of highly detailed military pieces that range from helmet accessories to highly detailed weapons. Most with a science fiction/video game twist.

Arealight Customs

Arealight Customs make fun and high quality custom accessory for anyone who enjoys customizing their own minifigure creation. Custom parts are made of high quality ABS and many are available pre-printed.

BrickArms

BrickArms sells WWII, modern, and sci-fi weapons, accessories, and helmets. All are made of injection molded ABS, and are available in multiple colors including gunmetal and electroplated chrome. BrickArms also sells custom-printed minifigures, complete with matching accessories. BrickArms sells over 100 different weapons & accessories, weapons packs, and custom minifigures.

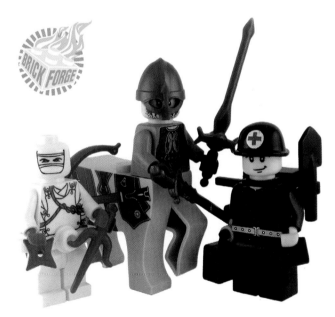

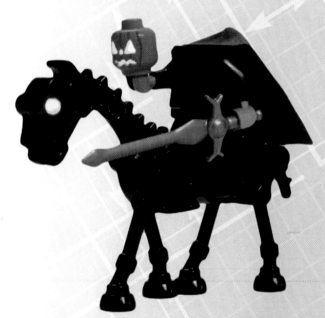

BrickForge

Brickforge provides the community with a unique assortment of custom minifigure accessories. Their catalog of over 100 specialized elements and 20 vibrant colors spans many themes including: fantasy, historical, modern and sci-fi; allowing minifigure enthusiasts to construct a variety of impressive characters.

Brickmodder/Lifelites

Lifelites Custom LED lighting kits and accessories allow for lighting modifications to be added to your MOCs, minifigures, and other scale models.

Custom Brick and Minifig - Christo7108

Custom Brick and Minifig creates a very high quality of custom LEGO scale items. These items include custom capes, glow-in-the-dark blades, head accessories and excellent custom figures. All our items are printed and are of a very high standard. Christo7108 is always ready to do new and exciting designs. Complete figures are available, but as they are only sold through eBay the price can vary from auction to auction, so be patient if you are after one of their parts or figures.

BrickTW

are partners from Taiwan with a deep passion for LEGO. They hope to create a paradise and invite all LEGO fans to join. Their focus is in the Asian historical theme, but they have a lot of innovative items too. They offer 480 components in different colors; resulting in an amount around 288,000 items in their store.

Little Armory

The Little Armory, which I believe is now closed, was the first third-party ABS parts supplier that I am aware of. They created simple yet elegant versions of the Star Wars weapons to outfit your custom figures. Many of these accessories are still highly sought after today.

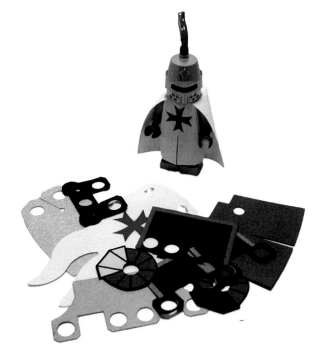

Fine Clonier

The Fine Clonier, my site, offers high quality waterslide decals for several genre as well as custom-cast and ABS elements. We strive to incorporate a style similar to LEGO when appropriate and deviate where we deem necessary. We offer thousands of designs which can be combined in infinite number of ways with LEGO elements to create an endless supply of custom figures.

MMCB

MMCB Custom Minifig Cloth Accessories specializes in making fabric accessories for standard LEGO Minifigures. Their designs range from basic capes through to highly detailed pauldrons, holsters, and tents. Each piece is made from specially treated fabric closely matched to LEGO colors. They currently have 90 different designs which are available in 33 colors. Most of these can have additional detailing (borders, emblems, camouflage) to make a total of 688 individual products.

Roaglaan Stickers

Most of Roaglaan designs are based on World War II and modern military themes, and they also have a few pirates and adventurers. The site's philosophy is to create decals and stickers in a style that complimentary to the LEGO design. Designs are provided as stickers or waterslide decals.

Saber Scorpion

Saber Scorpion's lair offers sticker sheets to create your favorite custom figure across many different films and games.

The Little Arms Shop

There is a cloud of mystery around how this shop started. The owner used to be a distributor for the Little Armory and then suddenly cut the Little Armory out of the picture. They offer many of the same items that the Little Armory did, so if you are desperately looking for one of their items check here.

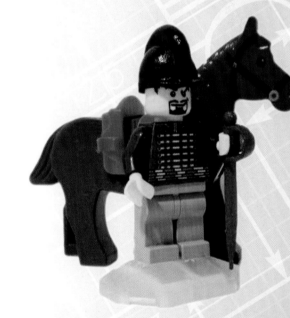

Unknown-Artist-Studio

Unknown-Artist-Studio is a hobbyist-owned and run online shop catering to AFOL's and customizers around the world. They offer intricately fitting fabric cloaks, coats, and holsters and sheaths that work with official and aftermarket elements. In addition to fabric, they also have resin cast accessories. Requests for custom colors and elements are always available.

It is readily apparent that the third-party market is a large and growing with many people making niche items. Understand your needs before shopping and buy only what is needed, or you could go broke quickly as many very interesting items are being produced.

MinifigCustomsIn3d

MinifigCustomsIn3d provides custom accessories in minifigure scale. The shop contains mainly hats for different topics (Napoleonic, Middle Age, Ancient, Fantasy, Military) and a small number of additional items like rifle, pistol, drums, mace, and more. Currently the shop has nearly 150 different items.

PLEASE NOTE: This chapter and the author does not endorse or vouch for any of these manufacturers so if you have concerns ,please contact their customer support people before purchasing. Also note the author owns the Fine Clonier.

Throughout this book we have discussed different ways to create custom figures. Once you have created them, how do you display them? Even if you don't have a large selection of custom minifigures perhaps you wish to display your official figures. How can this be done? Well, there are multiple products out there and multiple ways to use them. In this chapter we will visit the ones I am aware of and the ways I use them. I will also disclose a few ideas I have had to create some new options.

LEGO Minifigure Stand

Let's begin this review of the available display options by looking at what the LEGO® Group has given us (see left) to use to display our figures. I bet there are more than you realize and these options are typically the ones that best integrate into our LEGO collections. The most recent display stand that LEGO has given us accompanies the new "Minifigures" line. This simple little plate (Tile, Modified 4 x 3 with 4 Studs in Center: www. bricklink. com/ catalogItem. asp?P=88646 - see left) which is quite effective for displaying figures and is economically priced around twenty cents on Bricklink.

LEGO Sports Plate

This plate is also similar to the display plates that LEGO gave us a few years ago. These tiles (Modified 6 x 6 x 2/3 with 4 Studs and Embossed Letters: www. bricklink. com/ catalogList. asp?pg=3&catString=38&catType=P&v=2 - see left and below) came with a few sets and had the embossed words "Star Wars," "Sports," "Rock Raiders," "Ninja," or "City." These came in various colors and all but the "Star Wars" versions can be found for pennies on Bricklink making it an economical way to display your figures. This little stand features a card slot which means you could display your figure with a nice little printed backdrop or figure schematic.

When displaying my collection I use many of these stands along with a special board I had made. The plates slide into a special slot cut into the board that makes display shelves for the figures (see right).

At the New York Toy Fair 2011, LEGO showed us the most recent display box (below and below right), which will come in a variety of colors and sizes, stack and wall mount. These will be great for individual display or groups of figures.

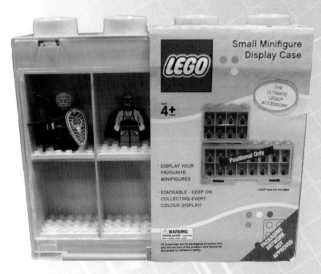

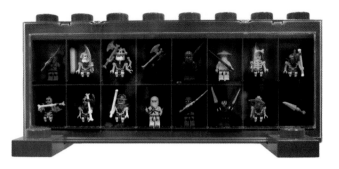

New LEGO Display boxes. Photo by Ace Kim.

However, let us not forget that LEGO has also supplied us with magnetic stands (Magnet, Brick 2 x 4 Sealed Base with Extension Plate with Hole: www. bricklink. com/ catalogItem. asp?G=74188), seen at right. These are likely the most economical currently as they are in high supply on Bricklink. They are also available in several colors. Much like my display boards described above these could be used in several creative ways to display figures. Just think of what could be done with these and a magnetic dry-erase board, at far right. To take it one step further, there are now magnetic paint primers. You could paint the wall of your LEGO space with a magnetic primer, use a colored paint over the primer and then display all your figures without placing a single nail in the wall by using these magnetic stands. This is how I have my LEGO room setup.

LEGO Magnetic Display & Magnetic Dry-Erase Board

These are the simple stands that LEGO has supplied. Using bricks and tiles you can create individual display stands, risers, and even display boxes, seen below. Being creative, you can build all sorts of displays to house your figures. The best LEGO brickbuilt display for a figure I can think of is a vignette. These are small scenes that capture the nature of the figures housed inside.

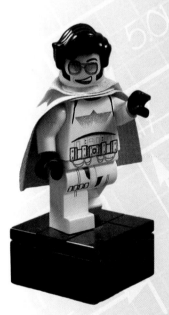

Custom Grevious with Brick Base, photo and custom by Larry Lars

Brick Stand, photo by Jared Burks

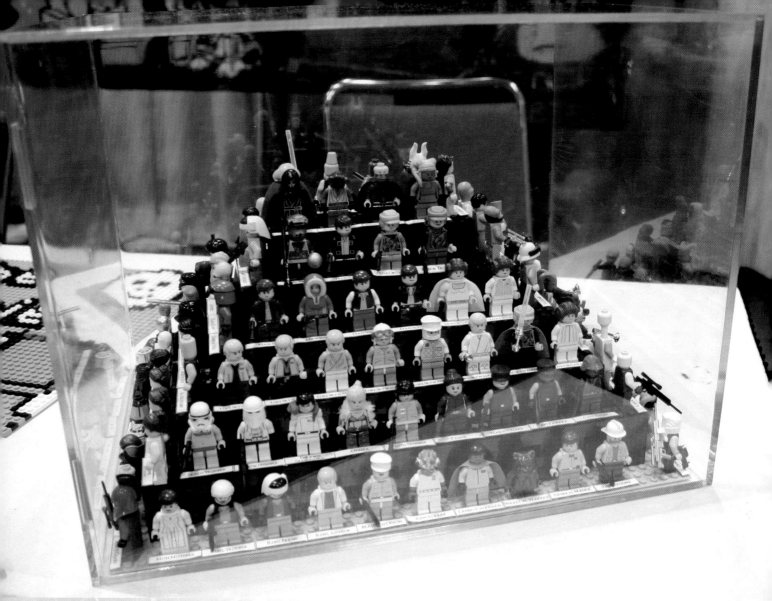

Pyramid display and photo by Ace Kim.

Brick Stands.

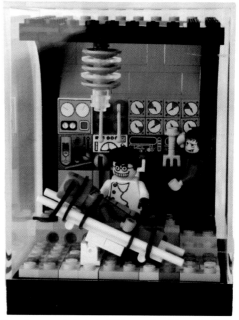

"Frankenstein's Lab." Photo by Matt Sailors.

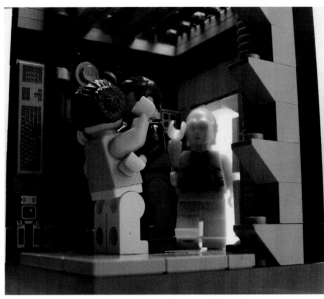

"Private Moment," a vignette by Jared Burks.

There are many commercial options available to use to display your figures. There are small plates available (right) from Minifig World (www.minifigworld.com/), as well as a few variations available from some other manufactures on the secondary market. If you want to keep your figures dust-free there are small acrylic boxes (below) and domes available to complete protect your figures. These can be combined with the brickbuilt LEGO stands to house your figure. Larger versions of these can also be found that allow for small groups of figures like the baseball box at bottom right.

Display Stands, photo by Mark Parker.

Acrylic Boxes, photo by Matt Sailors.

Baseball case. Photo by Don Reitz.

AMAC Boxes. Photo by Matt Sailors

These clear boxes with the black bases are from AMAC Plastics (www.amacplastics.com). These are in the Showcase Series from AMAC Plastics. AMAC Plastics sells these wholesale with a $100 minimum order, however the cases are available at some retail outlets online. The figure boxes shown are models 802C (the 3x3 insert size) and 805C (the 4x4 insert size).

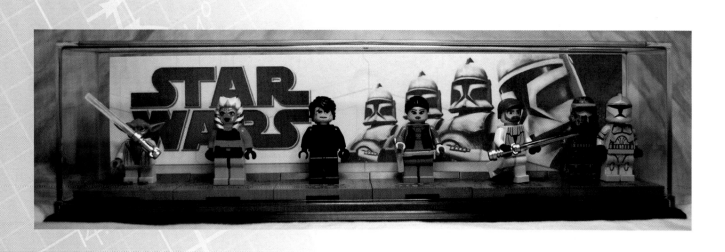

Autograph Display

There are a few larger acrylic boxes that are quite useful and widely available from the Container Store (www. containerstore.com/shop/collections/display/cubesCases). One that I particularly like has internal dimensions of 6 by 36 studs. This makes it perfect to display figures, especially if using the embossed LEGO plates mentioned above. This is what I use to house my autograph collection.

The round window displays are Cubisto brand, which are available in 3 sizes. In the US they are distributed by Basic Fun and are available from various online retailers including vendors in the Amazon Marketplace program and Buy. com. The ones with the figures are the small size. The product package photo shows the medium size. Cubisto Photos by Matt Sailors.

As you can see there are many ways to display and protect your figures. Get creative and look at some of the options above and try to think outside of the box. The best displays are the ones that are a touch creative. This chapter only scratches the surface of the options. You could include a mirror in the back, special graphics, or even lighting effects. Mirrors could be added to any of the above box options. Special graphics can be created much like the decals used to create the custom figures. Lighting effects could be easily incorporated using Brickmodder's Lifelites lighting systems (www. lifelites. com/). What can you come up with?

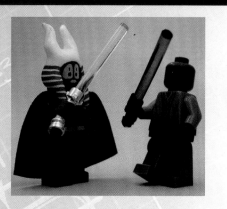

Macro Photo: In this figure we find two custom figures sparring. They are sporting custom-made sabre hilts made by Deathstickman of FBTB and MCN. Notice the clarity of the photo and the reduced shadows. When you take a picture be sure to examine the details.

Camera settings: 1. Note the location of the automatic settings as demoted by the A. To select this setting turn the dial to the A. 2. Note the location of the macro setting. Typically it is activated by depressing the button next to it twice, which results in the presentation of the flower icon on the LCD screen. However some cameras feature a wheel to select this setting.

Now that you have created figures and displays to house them, you need to share those creations. Typically this is done online, which means you need to photograph the figures. As they are small, you don't merely point and shoot. Photographing any small objects require that we think about a few important concepts and that we have a basic understanding of our digital camera. With a few simple tips ,you can dramatically improve the pictures you take with your camera. This chapter is directed at macro digital photography and is by no means an all-inclusive guide to digital photography. The point of this chapter is to help the typical user improve their digital photographs using a basic digital camera, so if you are a camera buff you might pick up a trick or two, but this is likely to be a review. In this chapter we will break down digital photography into 3 major sections: Digital Cameras, the Photo Studio, and Picture Editing (The Basics).

Digital Cameras

Every digital camera is slightly different, but they all have a few common elements; a lens, digital storage media (which replaced film), and typically a flash. Not all cameras use these three elements in the same way, so it is important to know how your digital camera works, especially as they all have unique or proprietary features. If you can't find your camera's user manual check out either the manufacturer's website or these quick guides (www. shortcourses. com/guides/guides. htm). I know what you are thinking: why do I have to read some user's manual if you are about to teach me how to do it? You will need to know how to turn on and off the special features we are going to discuss for your camera. The quick guides' site has an extensive database about digital photography and I highly recommend it if you have additional questions (www. shortcourses. com).

The greatest piece of advice I can offer when using your digital camera is that if a photo doesn't turn out as you had hoped, just delete it and take another picture. Take advantage of the power of digital photography, instant feedback; learn from the way you take your pictures. Don't be afraid to experiment, the pictures you publish will represent your work; make them as nice as your custom figure. With the instant feedback of digital cameras, a photographer should NEVER display a poorly lit or blurry image.

This chapter will assume that you are using your digital camera on the automatic setting, meaning the camera is choosing the exposure time, aperture, focus, and white balance. If you don't know how to set your camera to the automatic setting, please refer to your user manual or the guides listed above. In most cases, you will turn the dial on the top of your camera to the A setting,

Macro

When photographing a minifigure you should get the camera as close to the minifigure as possible, with a few minor exceptions. The reason for this is that the figure will

be larger in the final image, and after all, that is what you are trying to take a picture of to share with others. The minimum focal distance of your camera determines this distance; if you get too close the picture will be blurry (This distance is likely in the user manual for your camera). There are two ways to get close to the figure; one is to use your zoom lens, which has its drawbacks, and the other is to use the camera's macro setting.

Note that digital and optical zoom is not the same. Digital zoom sacrifices pixel size, which translated directly into image quality and resolution. Optical zoom uses magnification offered by a lens to increase the size of objects while not affecting the number of pixels collecting data. So if you decide to use the zoom options always and only use the optical zoom. The macro setting uses a lens to reduce the minimal focal distance of the camera, allowing you to place the camera closer to the figure than normally possible. The macro and zoom lenses can be used in conjunction with one another and we will go into the advantages and disadvantages of these options shortly. By getting closer you can fill or nearly fill the screen with your figure. Remember if you can't fill the screen with your figure you can always crop out the unwanted region of the image, however this will make the final image smaller.

I am sure that you have all seen those three little icons next to one of the buttons on your camera; the mountain, flower, and clock. This button (or wheel on some cameras) is used to activate the macro setting for your camera. The macro setting, represented by the flower, is toggled on or off with the other settings depending upon the number of times you depress the activation button. When the macro setting is activated, a flower icon is typically displayed on your camera's LCD. By using this feature you can now place the camera closer to the subject filling the capture area with the subject.

Depth of Field

Depth of field is the distance between objects in focus in your photograph. I am sure you have seen photographs where you have a long depth of field; meaning objects in the foreground, background, and everything in between are in focus. Conversely a shallow depth of field will only have the central object in focus and the foreground and backgrounds will be blurry. The depth of field is controlled by the aperture of the lens/exposure time, how close you are to a subject, and how much the lens is zoomed. Not all digital cameras have the aperture iris, thus they control depth of field with exposure time.

The lens aperture is the opening in the lens that allows light to pass through, it is controlled by an iris inside the lens. Since your camera is set to automatic, you don't have direct control of the aperture setting and thus depth of field. To check the f-stop, look at the f# on the LCD screen; the larger the number, f22, the greater the depth of field; the smaller the number, f2.8, the smaller the depth of field. Many digital cameras don't allow you to alter the aperture; however, you can affect the depth of field by controlling

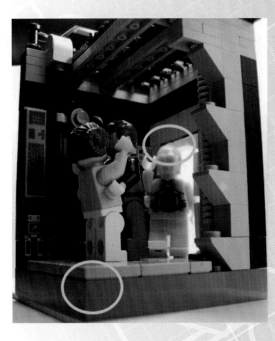

Depth of Field: *Note the difference in these two images of the same vignette. In the top photo, look at the two regions circled. These are the closest and furthest items in the photo, and they are out of focus and blurry. In the second image the lighting has been altered and a longer exposure time was used resulting in a larger f-stop, which increased the depth of field to bring these areas into focus. Depth of field can get so small that an entire minifigure isn't in focus. Be careful of lighting as this is the best remedy for a narrow depth of field.*

Narrow Depth of Field: *This figure was made for a special Houston TEXLug event, where it was photographed by Anthony Sava in a well-lit area. Anthony demonstrates a narrow depth of field in this photo, which removes the distracting background by blurring it in the image. The depth of field in this photo can be seen by examining the corners of the black box the figure is displayed on; notice the near and far corners are slightly out of focus.*

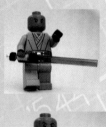

Resolution: *This series of images demonstrates what happens with the various resolution settings of your camera. This custom figure has been cropped out of a (top) 640x480, (middle)1280x960, and (bottom) 2272x1704 images; which results in several different sized images. When we post online we need a figure of approximately 400 pixels tall. This means that the 1280x960 would be a good starting size for our image, when we crop out the figure it is 614 pixels. This allows us to resample and resize the image to make it easier for others to download and view.*

the amount of light on your sample figure, which is why I bring it up. The more light you have on your subject the smaller the iris will open (the larger f#) the greater the depth of field; however, you can wash out your figure with too much light so be careful. When the subject figure is not well-lit, the iris opens more to allow additional light to enter the camera (the smaller the f#), which narrows the depth of field. This means the objects in your figure's hands might be out of focus while the main body of the figure is in focus.

There are three ways to combat a narrow depth of field when photographing figures; one is to make sure that the figure and anything they are holding are in the same plane of focus (Line them up in a straight line such that they are all about equal distance from the camera lens), the second is to use a wider angle of view (don't zoom in), and the third is to increase the lighting. Proper lighting can solve many of the depth of field issues; it will be addressed in the photo studio section shortly. You can take your camera out of automatic mode and adjust the aperture more precisely than by altering the light levels, distance to subject, or level of zoom; to do so please refer to your user guide.

Conversely, a shallow depth of field can be used by the photographer to isolate subject matter or make part of a photograph stand out to the viewer, so this is an area where experimentation is encouraged. Think about your photos before you take them decide what you are trying to capture; use them to show off or highlight your custom work.

Insufficient light/aperture opening can be one reason you get blurry photos. If the camera can not open the aperture wide enough to get sufficient light in automatic mode, it will extend the exposure time in order to get the additional light. When the exposure time is greater than 1/60 to 1/30 of a second you will detect motion in either or both your subject and/or in your hands as they hold the camera, thus blurring the image captured. If you can't get sufficient light on a subject figure, consider setting your camera on a stationary object or a tripod and using the timer feature. I suggest the timer feature as the act of depressing the button can cause camera movement and continue to blur your images on longer exposures.

Resolution

This is a tricky subject and one tends to think the higher the resolution, the better the image. After all, cameras with more mega-pixels have higher resolution and are more expensive, so they must be better, right? This is not necessarily true depending on your how you are going to display or print your photographs. Most of the time we use our digital photographs to post online or email to friends, we don't need a 2272 x 1704 pixel image to put on the web. We need a small image of approximately 400 to 600 pixels high. If you capture your image at the highest resolution your camera can capture, details not visible to the naked eye will be visible. This is because you have essentially placed the figure under a microscope. You are magnifying the figure by using the resolution in combination with the macro features. If you merely shrink this image to a smaller size this "magnified" view will still be visible, as well as the

larger file size. You will need to resample the image as you resize it in order to reduce the magnification effect and to reduce the file size. Another solution is to take images at a lower resolution. I suggest something in the 1280-1024 pixel size as this is a middle of the road resolution and will not create the "magnified" views as easily. Thus when you crop your image to the 400 pixel size it will appear as close to the lifelike item as possible.

Flash

There are advantages and disadvantages to using your flash. The flash will increase the light falling on your subject and thus increase the depth of field by using a smaller aperture (larger f#), which is good. The flash will also help remove any motion that might appear in your image from camera movement, which is also good. However if you want to minimize the shadows created from the light placed on the subject figure a flash isn't good. A flash will create a very hard/dark shadow region from the flash hitting your figure. Also if you are taking a picture of a subject with flat surfaces the flash could reflect off these surfaces and wash out your image. If you are going to use your flash make sure the light from the flash hits these surfaces at an angle so the light reflects in an angle away from the lens.

Photo Studio

A photo studio is made of a few elements; light source (typically 2), background, camera, and possibly a diffuser or reflector. The studio is fairly simple to set up and can be created on any desk or tabletop.

Desk lamps work well as light sources, it helps if they are the same type, but this isn't critical. Also, less color correction is needed if daylight corrected light bulbs are used. Merely place the light sources on opposite sides of the figure and angle the light such that it falls on the figure at 45 degree angles. This helps reduce the shadows as the two lights interfere with each other minimizing the shadows each light creates.

A seamless background can be created by using poster board or a sheet of colored construction paper. Merely find a tall object like a coffee can and attach the paper or poster board such that it drapes from the top of the object to the table top with a slight bend forward to form an L shape. You can change the background color to accentuate the figure. White and Black work well, but as there are many LEGO elements in these colors, therefore a neutral light grey or blue might be best, feel free to experiment.

Light diffusion is the next trick to work out for your studio. There are commercially available diffusers called Light Tents (check eBay), which will give you professional results. However you likely have all the tools in your house to make a diffuser. If you have a 1 gallon plastic milk jug lying around, you have the perfect diffuser for a minifigure or anything of like size. Start by cutting the bottom off the jug, then cut off the handle, making a flat open side, and finish by cutting a hole in the lid large enough for your camera lens. Make sure you remove any labels. By laying the jug on

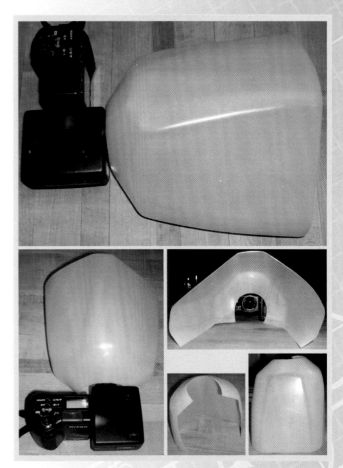

Milk Jug Photo Studio: *This is a great and inexpensive light diffusion system that allows for well lit pictures. In this setup I have used two different fluorescent lights to light the figures. It might be better if two halogen (Day light corrected bulbs) desk lamps were used, but I used what was on hand. The milk jug cut in half works well to diffuse the light and minimize the shadows. By using a piece of colored construction paper a seamless background is created that allows for easy photo editing. Remember you can pull the edges of the milk jug together to make the interior space taller to allow larger items, however the milk jug setup is really too small for anything much larger than a minifigure.*

Advanced Photo Editing: *This photo by Ace Kim of FBTB demonstrates photo editing at its best. Notice how well he has captured Boba Fett with this simple yet imposing pose. The lighting and pose capture Boba's arm and leg decoration. While we will not be getting into this advanced photo editing, it is good to examine these photos for creative ideas.*

its side you can place your camera on the table and slide the lens into one end and the background into the other. Then shine your lights onto the figure through the jug, which diffuses the light and eliminates shadows.

One last comment on composition: even though you are taking a picture of a figure in a static environment, it doesn't mean you should "pose" the figure as if something is going on around it. Make it have bold action, turn its head, place items in its hands — breath life into your figure and your photograph.

Picture Editing (The Basics)

Now that you have captured a few images of your favorite new custom figure and you really want to share, make sure the pictures are the best. Load them onto your computer from your camera and start editing. Editing is where a lot of experimentation can occur. To convert your color image to black and white, darken the image, crop out excessive background, all is possible and only limited by your imagination. There are many programs on the market for photo editing, with the leader in the field being Adobe Photoshop, followed closely by Corel PhotoPaint.

These are very high-end programs. However there are several freeware/shareware programs that can be used as well (Check www. tucows. com). One that I particularly like is called Irfanview (www. irfanview. com/). This program is very small, yet very powerful.

Cropping

With Irfanview you can crop your images by merely drawing a box around them and then using the crop command under Edit > Crop. One of the nice features is that you can resize the box instead of having to redraw it.

Enhance Color Options

Under the enhance color options you can adjust the color balance, brightness, contrast, gamma correction, and saturation. This will allow you to fix any imbalances in your photos caused by the lighting you use. Without a long explanation, the colors we see are directly affected by the light that shines on them, so if you use fluorescent light, tungsten (incandescent), or candlelight you will get very different shades of color; this is a way to correct the colors in your photo. This area requires experimentation and deciding what looks best to you. If you need additional information on these different image settings I suggest this article: www. shortcourses. com/editing/index. htm

Resize/Resample

Of course the minimum editing required is resizing or resampling. When you resize an image you merely make it larger or smaller, however when you resample you change the number of pixels in an image. Upsampling uses interpolation to increase the number of pixels; where as Downsampling throws away pixels to reduce the size. It is best to resample your images when you resize them, making the file sizes smaller for faster load times. It is always better to shrink or downsample an image than it is

to enlarge or upsample. This way you are removing "extra" information as opposed to having to use interpolation to create information.

Irfanview doesn't stop there, it has many additions that can be installed allowing you to not only alter the image by converting it to black and white or sepia tone, but gives you a wide variety of photo alterations. Play with your pictures and see what you can create. Just remember to be polite when you post your image, as much of the world is still on dialup modems and it can take them some time to download your 4000 x 5500 pixel image. Keep your large original image for printing purposes, but share a smaller file that makes it easy for all to enjoy.

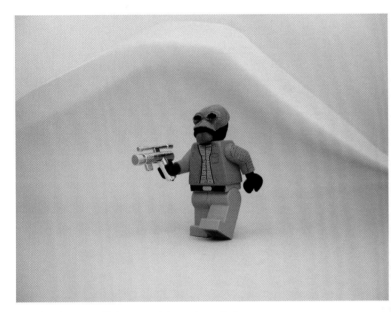

Basic Photo Editing: *In this series of photos we can see the progression of photo editing. In the first image we see the initial photograph. This image is then cropped, balanced for light, color, and then the image is extracted in Photoshop. With this custom figure extracted he is ready to be overlaid on a special background to make a custom image.*

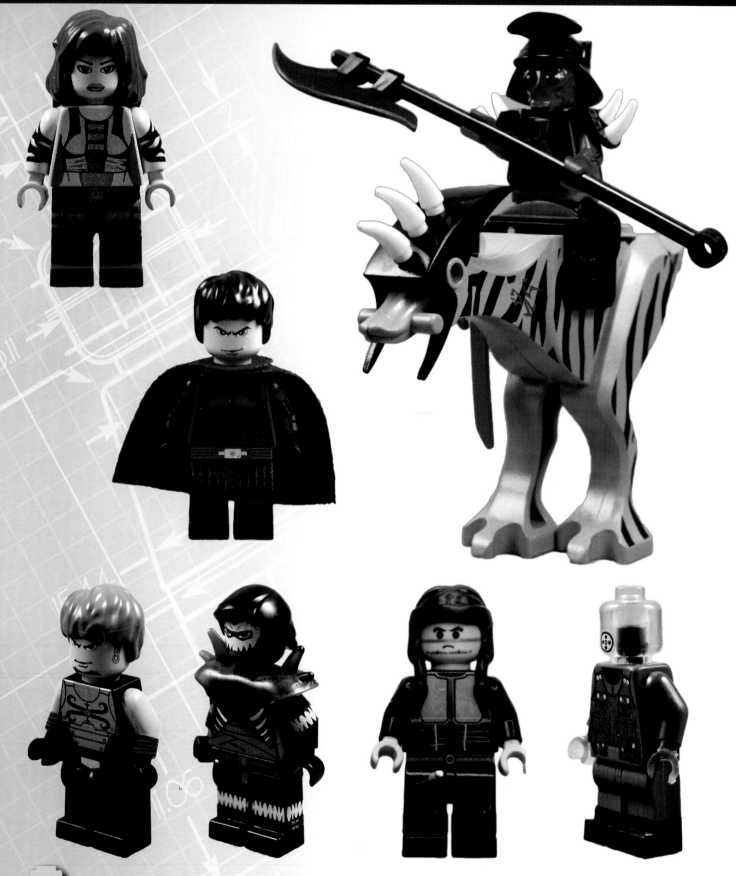

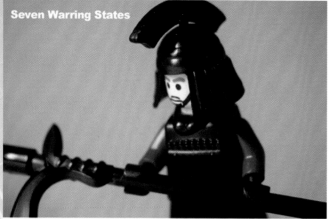

Seven Warring States

金色八旗装備
金色八旗盔甲, 金色八旗頭盔, 金色頭盔十字棍

拍攝者 / tigerggyy

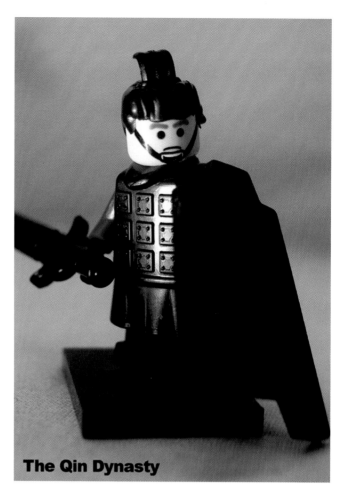

The Qin Dynasty

Credits:

Darth Hsan pg 74 and Mount by Nick Sims & Jared Burks, Mandalorians pg 75, female and Jedi Mandalorians pg 76 by Michael "Xero_Fett" Marzilla, Boba Fett and The Bride pg 76 by Kris "DrVenkman" Buchan, Iron Man pg 76 by Chris "Uubergeek" Campbell, Twileks pg 77 by Bluce "Arealight" Shu, The Qin Dynasty pg 78 by Kevin Chu, all others by Jared "Kaminoan" Burks.

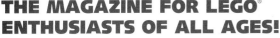